Only in BOULDER

THE COUNTY'S COLORFUL CHARACTERS

Silvia Pettem

THE
History
PRESS

Published by The History Press
Charleston, SC 29403
www.historypress.net

Cover images: On the front cover are Edith DeLong and Ivy Baldwin. On the back are Joseph Bevier Sturtevant, Charles Parsons and two unindentified men at the First National Bank. *All photos courtesy of the Carnegie Branch Library for Local History, Boulder Historical Society Collection.*

First published 2010
Second printing 2013

Manufactured in the United States

ISBN 978.1.59629.975.7

Pettem, Silvia.
Only in Boulder : the county's colorful characters / Silvia Pettem.
p. cm.
Includes index.
ISBN 978-1-59629-975-7
1. Boulder (Colo.)--Biography. 2. Boulder County (Colo.)--Biography. 3. Boulder (Colo.)--Social life and customs--Anecdotes. 4. Boulder County (Colo.)--Social life and customs--Anecdotes. 5. Boulder (Colo.)--History--Anecdotes. 6. Boulder County (Colo.)--History--Anecdotes. I. Title.
F784.B66P49 2010
978.8'630099--dc22
2010015344

Contents

CONTENTS

Contents

Part VII. Unusual and Legendary

Acknowledgements

M any people contributed to this book, but I would like to thank those who helped the most—my editors at the *Daily Camera*, the librarians at the Carnegie Branch Library for Local History and the trustees of the Boulder History Museum.

Only in Boulder: The County's Colorful Characters is a collection of sixty history columns first published (and reprinted with permission) by the *Camera* during the years 1998–2010. My first editor was Maria Cote, followed by Jay Dedrick, Lisa Marshall, Sandra Fish, Greg Glasgow, Erika Stutzman, Cindy Sutter and Dave Burdick. Special thanks also go to former *Camera* librarian Carol Taylor, past executive editor Thad Keyes and present executive editor Kevin Kaufman.

Wendy Hall, Mary Jo Reitsema and Marti Anderson—of the Carnegie Branch Library for Local History in Boulder—offered invaluable assistance in helping me select and procure photographs that best illustrate the stories.

I'm grateful, too, to Nancy Geyer, executive director and CEO of the Boulder History Museum, for the museum's partnership with this project, which allowed me the use of several of the museum's photographs. The Colorado State Archives and Alan Cass contributed photographs, as well.

PART I

Early Residents and Visitors

CHIEF NIWOT'S "CURSE" WAS AN EARLY ATTEMPT AT GROWTH CONTROL

In November 1858, when the first gold prospectors settled in for the winter near what is now Boulder, Colorado, a tribe of Arapahos was camped nearby. No one recorded the conversation, but Arapaho chief Niwot (also known as Chief Left Hand) supposedly claimed that the Boulder valley was so beautiful that people seeing it will want to stay—and that their staying will be the undoing of its beauty.

The chief's comments, which folklore has renamed his "curse," was most likely an early attempt at growth control.

The story was first recorded twenty-two years later by journalist Amos Bixby in his 1880 history of Boulder, published as part of a larger volume titled *History of Clear Creek and Boulder Valleys, Colorado.* Bixby related a verbal account given by Captain Thomas Aikins, one of the prospectors, who said that the chief had assumed an air of authority.

"Go away," Chief Niwot had commanded. "You come to kill our game, to burn our wood, and to destroy our grass." According to Bixby, the chief had intended to drive off the white men, but "the crafty gold-seekers fed and flattered him until he promised that his men and the prospectors would live together in peace."

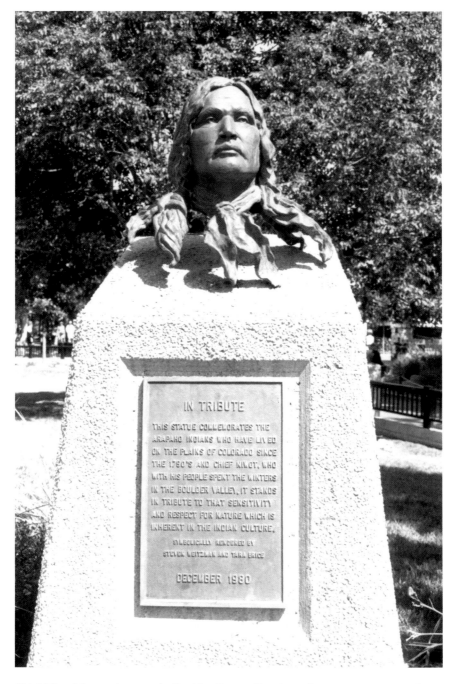

Chief Niwot's bronze bust, on the Boulder County Courthouse lawn, commemorates the Arapahos who preceded the miners and settlers in the Boulder area. *Photo by the author.*

Another chief, Bear Head, thought that Chief Niwot was making a mistake. Bear Head went to the prospectors' camp and began his complaint with a superstitious allusion to a comet then visible in the night sky.

Bear Head asked the prospectors if they remembered the year 1832—when the "stars fell." Pointing to the comet, he asked, "Do you know what that star with a pointer means?" Then he was quoted as saying, "The pointer points back to when the stars fell as thick as the tears of our women shall fall when you come to drive us away."

In his account, Bixby stated that Bear Head turned and gave the gold-seekers just three days in which to leave the region. In the Indian encampment, Manywhips, an orator, harangued each night, concluding every sentence with the words, "Something must be done!" In flowery prose, Bixby wrote that "all the squaws made mournful response, in their style of savage chorus."

On the morning of the third day, Chief Niwot approached the well-fortified log house of the gold prospectors alone. As noted by Bixby, he bowed low, and "feigning humility and distress, he was invited in."

Chief Niwot then related a dream. He said that he had stood on a hill and watched Boulder Creek swell to a flood. His people were swallowed up by the rush of waters, while the white people were saved.

"It was supposed that this story, the invention of savage imagination," stated Bixby, "was made up as an excuse for declining to fight for the possession of the country, as the Indians had threatened to do."

The Arapahos had avoided conflict with a face-saving solution. They moved on but left behind their names. Among locations we have Arapahoe Avenue (with an *e*), Arapaho Glacier (without an *e*), the town of Niwot, Niwot Ridge, Left Hand Creek and Left Hand Canyon, as well as numerous businesses named Arapahoe, Niwot and Left Hand.

Was Chief Niwot trying to tell us something? You decide.

A Century Ago, Emma Brookfield Was Boulder's Oldest Old-timer

When Boulder celebrated its fiftieth birthday in 1909, practically everyone in the town of nine thousand knew Emma Brookfield. Her late husband, Alfred Brookfield, had come west with the first party of gold-seekers and

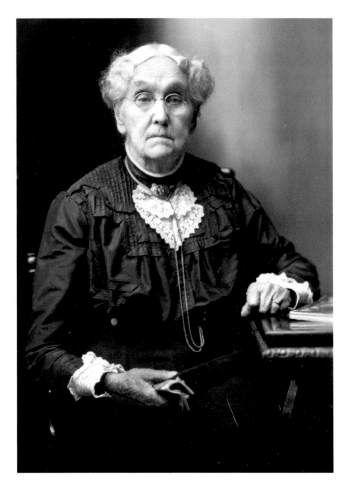

Emma Brookfield, one of Boulder's first female settlers, reigned over the city's semicentennial celebration in 1909. *Courtesy of the author.*

had served as president of the Boulder City Town Company—founders of the city on February 10, 1859.

Emma was one of Boulder's first female settlers. At the city's 1909 semicentennial celebration, newspaper writers called her "Boulder's grand old lady" and honored her as the city's oldest surviving old-timer.

Initially, however, Emma had remained in Nebraska City, a Missouri River town in eastern Nebraska Territory where thirty-four-year-old Alfred had been the town's mayor, as well as a grocer and dealer in agricultural implements. Then, early in 1859, he wrote to his bride, "We thought that as the weather would not permit us to mine, we would lay out and commence to build what may be an important town."

When the weather cleared up, so did Alfred's prospects. In the middle of June 1859, he returned to Nebraska City for his wife, as well as to close down his prior business interests. He also carried with him several gold specimens to show his friends and the press. The Brookfields left Nebraska City for Boulder in mid-September, traveling in a wagon train of eleven wagons, sixteen men and five women.

At first, the couple made their home in the mining camp of Gold Hill. Then, like many other early day miners, Alfred traded his pick and shovel for a plow and moved to the plains. He and Emma farmed a 160-acre homestead near the town of Valmont, a few miles east of Boulder.

The Brookfields moved again in 1865 to run a hotel in the mountain town of Ward. Seven years later, they purchased the Colorado House Hotel in Boulder, but newspaper writers commented less on their work and more on Alfred's increasingly poor health.

Eventually, "Old Brook" (as residents called him) was committed to the state insane asylum in Pueblo, Colorado, where he died in 1897. Meanwhile, the townspeople referred to his widow, Emma, as "Auntie Brookfield."

At the time of Boulder's semicentennial in 1909, the eighty-eight-year-old old-timer was the unanimous choice for queen to preside at a pioneers' banquet with twenty "maids of honor." These young women each represented either a Boulder County mountain town or a grange hall on the plains.

Emma Brookfield was one of eight Boulder women included in the book *Representative Women of Colorado*, published in 1911. She died in Boulder in 1914 at the age of ninety-three. Alfred had been buried at Columbia Cemetery, but Emma later moved him to Green Mountain Cemetery, where she was laid to rest beside him. The Brookfields did not have any children.

In a 1909 article titled "Boulder's Most Beloved Citizen," a newspaper writer described Emma as having a "face of kindly old age," emphasizing that she was proud of her age as well as her youthful vigor. Noted the reporter, "Boulder, too, is proud, and rejoices that it is able to call her Queen."

JACOB ADRIANCE PREACHED BOULDER'S FIRST RELIGIOUS SERVICES

In 1904, retired Methodist preacher Jacob Adriance dug out his diaries and wrote a detailed eight-page account to a colleague, telling him about his first visit to Boulder in August 1859. Adriance, twenty-four years old at the time, had ridden a pony from Denver to the frontier community just six months after Alfred Brookfield and his group of gold prospectors had officially founded the town.

The young circuit-riding preacher had been sent by the Methodist Nebraska Conference to establish a mission at the foot of the Rocky Mountains. Based in the Denver area, he included Boulder and several of the mountain towns in his rounds.

Circuit-riding Methodist preacher Jacob Adriance led Boulder's and Gold Hill's first religious services in 1859. *Courtesy of the Carnegie Branch Library for Local History, Boulder Historical Society Collection.*

Adriance described his first view of Boulder as a town of "10 or 12 log houses, but none of them completed, and 75 or 100 people mostly living in wagons and tents."

Outdoors, on the first Sunday after his arrival, he preached Boulder's first religious service. In his account, Adriance noted that his sermon was attended by about fifty residents who "seemed to be interested." Most of the population at the time was composed of men.

A few days later, the young preacher rode into the mountains via Left Hand Canyon and stayed, and prayed, with several families. Upon his return to Boulder, he found that a saloon had been completed. Since it was the largest building in town, he held his next service on the drinking establishment's second floor.

In September 1859, Adriance was back in the mountains, this time at what was then called "Twelve Mile Diggings," the early name for the mining community of Gold Hill. There he preached in a store and wrote that he "slept on the ground with a stone for my pillow." Dedicated to his work, he made several trips back and forth between Boulder and the mountain towns, sometimes walking when his pony was "lost" or "too thin."

When winter came, Adriance noted that even though the weather was cold he preached in a windowless cabin with the door open to let in enough light so that he could read the scripture.

Adriance preached in Boulder again during the summer of 1860. This time he returned with his bride, Fanny, and noted that she necessitated "the hiring of another pony." Since the weather at that time was hot, the couple (with Fanny on a sidesaddle) rode back to Denver by moonlight, with a large wolf accompanying them "a little in the rear for part of the way."

The couple returned to Boulder again in February 1861. Adriance then found the town "more settled and permanent." On that visit, he preached twice on the same day in the town's new frame schoolhouse.

According to a *Boulder Daily Camera* article in 1909, Adriance returned to Boulder a half century after his first visit. This time, he arrived on a train and visited with pioneer Boulder Methodists. He died in 1922 at the age of eighty-six.

In fond reflections of the early days of his career, Boulder's first preacher wrote to his friend that "meditation is sweet, and singing the old hymns is comforting." He concluded that "the religion of the Bible wears well."

Peter Housel's Memory Now Preserved with Gravestone

When Peter Mandeville Housel died in April 1905, friends and relatives climbed into carriages to follow his horse-drawn hearse from the First Presbyterian Church in Boulder to Green Mountain Cemetery, then still out in the country.

The *Boulder Daily Camera* had announced Peter's son James's arrival from Cripple Creek for the funeral. Ninety-four years and a few months later, James's son, Jerry Winters Housel, came from Cody, Wyoming, to pick out a stone for his grandfather's grave.

"I think it's very important for Boulder and for my family to perpetuate his memory," said eighty-seven-year-old Jerry Housel of the grandfather who died before he was born. "He never had a stone, and it's time that he had one."

Peter Housel, a prominent Boulder settler and the county's first judge, finally received a gravestone after ninety-four years. *Courtesy of the author.*

Peter Housel was Boulder County's first judge, a position that held great prominence in the frontier community. A granddaughter later recorded, "Grandfather was a reasonable and diplomatic man and everybody liked him. These qualities eventually led people to settle their disputes."

Peter had other occupations as well, though. In 1859, when gold was discovered west of Boulder near the mining camp of Gold Hill, he left his home in Newton, Iowa, and headed west, where he worked as a watchmaker, silversmith and jeweler. He built a log cabin and then sent for his wife Eliza, son Edgar and baby daughter Julia.

The day after their arrival, a fire burned the cabin to the ground. The only possessions the family could save were the dirty clothes that Eliza had put in tubs of water to soak. The Housels rebuilt and lived for a few years in the struggling mining camp where Peter had a part-interest in the Horsfal Mine.

Then, in 1866, Peter moved his family to Valmont, east of Boulder, where he purchased farmland. By then, his second son, Will, was four years old. His youngest son, James (who was Jerry's father), was still a baby.

Peter built for his family a frame home, since enlarged and presently owned by the Keeter family. Peter also formed a partnership with farmer John DeBacker and built a water-powered flour mill. The men sold and delivered barrels of flour to Gold Hill and other mountain mining towns.

In the early 1870s, when Jerry's father was a young boy, the Housels moved to a farm at Seventy-fifth Street and Arapahoe Avenue. Peter's wife Eliza died there in 1889 and was buried at Boulder's Columbia Cemetery.

Two years later, Peter married Louisa Wolcott, a widow with three sons. When Peter died in 1905, at the age of eighty-two, Louisa buried her husband at the newly opened Green Mountain Cemetery. By the time his estate was settled, no funds were left for a stone.

Peter's children were outraged, not because there was no stone but because their parents weren't buried together. So they moved Eliza and her stone to the new cemetery so she could be next to him. Louisa died in 1917 and was buried on his other side. Next to her is the reinterred body of her first husband, Horace Wolcott.

The writer of Peter's obituary eloquently stated that Peter had "gone over the range." Until recent research revealed his unmarked grave, family members had long wondered where he was.

(Note: Peter's son, Will Housel, secretly married Mary Rippon.)

PROSPECTOR "INDIAN JACK" DIED IN POVERTY

Lew Wallace, also known as "Indian Jack," located one of Boulder County's most prosperous gold mines. Instead of enjoying a life of leisure, his wealth slipped through his fingers and he died a poor man.

Accounts of Indian Jack's early life are sketchy. He was part Indian, although no one in Boulder knew much about his background. Born in New York, he was reported to have served as an Indian scout with the Fourteenth New York Cavalry in the Civil War.

Eventually, he moved to Boulder and worked at odd jobs, but his claim to fame was in Jamestown, a few miles northwest of Boulder. In 1875, he prospected with partner Frank Smith. The men found valuable gold ore and staked the now famous Golden Age Mine. Not realizing its worth, they sold

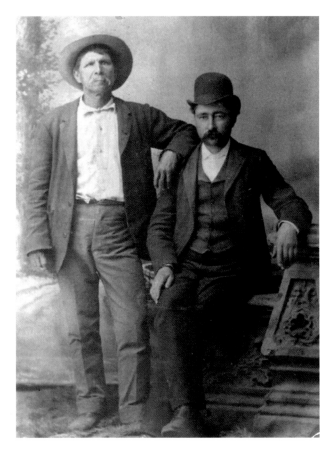

"Indian Jack," *left*, posed in the 1880s with one of his gold prospecting partners, "crazy" George Bittenbender. *Courtesy of the Carnegie Branch Library for Local History, Boulder Historical Society Collection.*

out for $1,500. The new owners deepened the shaft to three hundred feet and immediately recovered a profit of $40,000. They sold the mine a few years later to Chicago investors for $194,000.

Indian Jack continued to prospect, but he was never as successful again. According to newspaper reports, one of his partners was George Bittenbender, later ordered by the courts to the state insane asylum in Pueblo for being "crazy as a loon."

In October 1893, Indian Jack was struck with what the *Boulder Daily Camera* called "a tedious siege" of typhoid fever. Friends took him to the county poor farm, where he died at the age of seventy-three. He was buried at public expense in a plot set aside for the indigent at Columbia Cemetery.

Four months later, the Boulder County Commissioners realized that Indian Jack was a veteran and that they had made a mistake to bury him in a pauper's grave. Indian Jack's body was exhumed. A reporter stated that those who doubted that "Lew" was buried at the Boulder Cemetery were "given an opportunity to see his remains." Indian Jack was reinterred in a plot provided by the Grand Army of the Republic, an association of Union veterans.

Years later, writer Forest Crossen interviewed three men who had known Indian Jack as children. Roy Dunbar, one of the old-timers, said that all the children liked him, even though he was "ugly enough to stop a clock."

They recalled that when Indian Jack came out of the mountains and down to Boulder he'd stay at the Boulder House, a hotel on the northeast corner of Pearl and Eleventh Streets. He cut firewood to pay for his room.

People in Boulder liked him, too. According to the men who knew him, his only enemy was the whiskey bottle, but he never was in any trouble. "They had a bench over there where the *Daily Camera* is," said Frank "Baldy" Sisson, another of the old-timers. "He used to get drunk and go over there and sit on that bench. Never bother nobody."

One of his old friends said that there was a marker on Indian Jack's grave, but that has long since disappeared. No one seemed to remember much of his discovery of the Golden Age, either. The writer of his obituary called him a "drunken, harmless, good-natured fellow."

It was the closest he got to an epitaph.

INDEPENDENT BOOKSTORES WERE FAVORED BY BIXBY

Boulder Bookstore recently celebrated thirty-five years in downtown Boulder, but independent bookstores on Pearl Street are nothing new. Instead, they uphold a long tradition and were praised in the city's early days by *Boulder County News* editor Amos Bixby.

"If loafing is ever excusable, it's in a bookstore," wrote Bixby in 1877. At the time, both Stone's Bookstore and Fonda's Drug Store sold books in

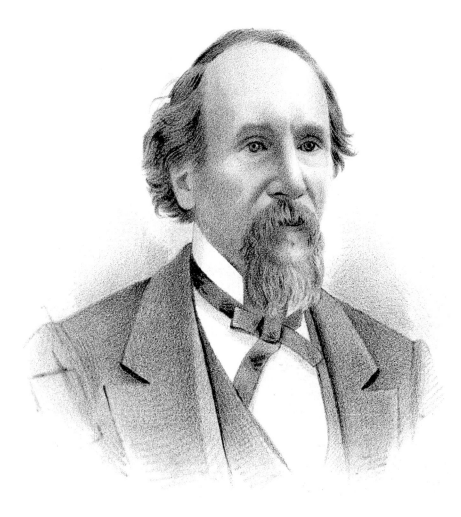

Newspaper editor Amos Bixby was one of Boulder's first bibliophiles. *Courtesy of the Daily Camera.*

downtown Boulder. Bixby sought out the businesses as good places to relax after a long day in his office.

He once wrote that he could go into any town, note the number and kinds of books sold and then be able to determine "the high or low standard of the general intelligence and culture of the place." Boulder rated favorably.

In his editorials, Bixby compared books to people, saying that some are dignified and stand back while others "court the glance of human eyes and the touch of human hands."

The hands-on approach was welcome in Stone's Bookstore. Although the proprietor, W. Stone, kept his gilded leather-bound Shakespeare, Burns and Tennyson books on the store's top shelves, he displayed the current bestsellers on a bookstand for everyone to read. According to Bixby, they usually included the latest book by Mark Twain.

By 1879, Stone had left Boulder, but Alvin and Sarah Sawyer, husband and wife, opened Sawyers' Bookstore on Pearl Street—probably in Stone's previous location. Both the Sawyers and Fonda stores were in business when W.C. Lewis opened the City Bookstore. In addition to selling books, Lewis also sold toys and stationery.

According to Bixby, the best new books were from unknown authors who related true experiences of human life. He lamented in his editorials that really good books illustrative of Colorado life had not yet appeared, and he predicted a fortune for books on the new state, which he called a "land of adventure and trial."

Perhaps in response to Bixby's remarks, Boulder resident A.L. Palmerton began writing *History of Boulder County*. According to an 1880 newspaper report, Bixby only edited Palmerton's work, but Bixby's name ended up as its author. The work (including the account of Chief Niwot) became part of a larger volume titled *History of Clear Creek and Boulder Valleys, Colorado* and was published when Boulder County was only twenty-nine years old.

The book's publisher chose to sell it by subscription rather than through the bookstores. Bixby may have missed seeing "his" book on the bookstore shelves, but a number of the books probably passed through his hands. By the time it was in print, Bixby had retired from the newspaper business to become Boulder's postmaster.

Today, the original book is a collectors' item worth more than $800. A 1971 reprint sells for more than $100.

The cost of books was justifiable to Bixby, who wrote in his time, "There is no other money so well expended as the little let slip for books." If he were alive today, he probably would be walking the Pearl Street Mall, looking for a bookstore.

Mary Rippon Received Posthumous Honorary Degree

Mary Rippon was the first female professor at the University of Colorado, where she taught for thirty-one years. Many of her students went on to earn advanced degrees, but "Miss Rippon" (as she always was called) never had a degree of her own—not even a bachelor's. That would change. At the University of Colorado's commencement in Boulder, in May 2006, the regents awarded a posthumous honorary doctorate to their legendary pioneer educator.

Said Regent Cindy Carlisle, "This award is long overdue."

Rippon was born in Illinois in 1850. Her father died when she was a baby, her mother abandoned her and she was passed around an extended family. When the young woman graduated from high school in 1868, she inherited money from the sale of her late father's farm. She had planned to go to the University of Illinois, but it didn't admit women.

Instead, Rippon traveled to Europe, where she ended up staying for five years. While there, she attended university classes in Germany, France and Switzerland. She also kept in contact with her former high school chemistry teacher, Joseph Sewall.

When the University of Colorado (CU) first opened in September 1877, Sewall was its first president, and he invited Rippon to join the faculty. At the time, there was only one other professor, and the entire university was housed in one building, now called Old Main.

Rippon, then twenty-eight years old, arrived on the train in January 1878 and lived in Boulder for the rest of her life. CU has always admitted women. The new professor was well liked and quickly became a role model to female students. Beginning in 1891, she chaired the Department of Modern Languages (later the Department of German Language and Literature).

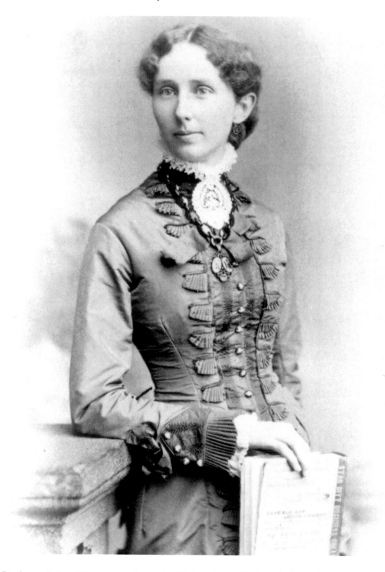

Professor Mary Rippon taught at the University of Colorado from 1878 to 1909. In 2006, she finally received a posthumous honorary degree. *Courtesy of the* Daily Camera.

Before long, Rippon was known as an exceptional professor who was highly revered by both students and colleagues. And she kept a low profile—for good reason.

When Rippon was thirty-seven years old, she had a romantic relationship with a twenty-five-year-old student. She and the student, Will Housel,

secretly married. Their daughter, Miriam Housel, conveniently was born in Germany while Rippon took a year's sabbatical. The couple (who never lived together as man and wife) left the baby in a European orphanage. Determined to keep her job, Rippon resumed teaching at CU as if nothing in her life had changed.

From then on, Rippon led two separate lives. In the Victorian era, married women didn't work, as society deemed it as taking a job away from a man with a family to support. Ironically, Rippon financially supported her daughter, even after Housel remarried and was able to give their daughter a home.

Rippon retired from CU in 1909, but she remained in Boulder until her death in 1935. Her private life was known only to two close friends, even during the years that her daughter (now deceased) also taught at CU. Miriam's son, Wilfred Rieder, announced his relationship to the university community in the 1980s. And his son, Eric Rieder, came to Boulder to accept the long-sought degree for his great-grandmother.

"Rippon shattered the glass ceilings of the day," said Carlisle. "Not only was she a scholar and a teacher, she was a revolutionary. She was a magnet for students who were ready to break the mold."

Rippon's honorary degree was granted on May 12, 2006.

FORREST JONES IS A LEGEND IN SUNSHINE

When Forrest Jones was a boy growing up in the mountain town of Sunshine, he attended classes in the community's one-room school (now 110 years old). Jones spent most of his life in the former gold mining town, and the stone schoolhouse is the kind of place where you almost expect him to walk in the door.

Sunshine is located only eight miles from Boulder, but it's off the beaten track. Every year, on the last weekend in September (when the aspen trees are at their height), local residents hold an arts, crafts and bake fair in the school. Since its classroom days are over, the weekend event is a rare opportunity to look inside and step back in time.

"I think it's important that young people know some of the history," the late Jones noted in a booklet, *The Back-History of Sunshine As I Recollect It*, that

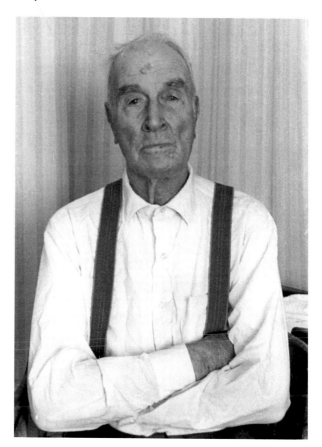

Forrest Jones lived his entire life in and near the Boulder County mountain town of Sunshine. *Photo by the author.*

he wrote in 1983. "There aren't many people around who remember as far back as I do."

Jones, one of four children of a Welsh miner, was born in Sunshine in 1897. During his childhood, his family moved back and forth between the Forrest Jones cabin and a ranch on Sunshine Canyon Road. At the ranch, the Jones family raised cattle for beef and milked cows for butter.

In addition to the schoolhouse, Sunshine had several gold mines (most notably, the American, the Interocean and the Monogahela), a post office, a grocery store, two hotels, a bakery and a saloon.

Electricity reached the town in 1940, although some of the surrounding mine surface plants had electric power as early as 1929. Water was pumped from a community well and hauled in barrels to individual homes by a horse-drawn wagon.

Jones never drove a car, but he remembered when, in 1906, he saw his first automobile, a Reo. The townsfolk were excited, but he thought that the early cars were unreliable, stating, "They worked, but you had to push them sometimes."

Throughout the years, Jones became the unofficial caretaker of the Sunshine Cemetery. His interest in the cemetery started in 1921 when his family moved the body of his maternal grandfather from the cemetery in the nearby town of Salina to the one in Sunshine.

As a young man, Jones helped to dig many of the graves. "Seven or eight men would take turns for one or two days," he said in an interview in 1984. "We'd drill by hand, blast and dig with a pick and shovel." Jones also set up the four cornerstones that mark the cemetery's boundaries and strung the barbed wire that hangs between them.

Everyone knew Jones, and he kept track of everyone else, compiling a list of 157 burials (dating from 1875) at the Sunshine Cemetery, which he donated to the Carnegie Branch Library for Local History. Now he has been added to the list: he died in 1989 at the age of ninety-two.

Jones never married and is buried with his siblings, parents and grandparents under the lilacs that the family planted years ago. "I put some roses in," he once stated, "but they didn't grow."

MARY BRADFORD ROVETTA REFLECTS ON CHAUTAUQUA CHILDHOOD

When Mary Bradford Rovetta was twelve or thirteen years old, she and her friends climbed up a ladder inside the auditorium at Chautauqua Park and crawled through a trapdoor to play in the turrets on the roof. A program started, so the only way down, they thought, was to climb down a tree. But a gardener was waiting at the bottom, and he spanked each of them as they reached the ground.

"The whole park was our playground," recalled Rovetta, who first arrived in Boulder as a babe in arms in 1915. She has returned nearly every summer to the cottage her parents built following their first visit in 1898.

Last week, before she left for her winter home in Florida, she reflected on her Chautauqua childhood.

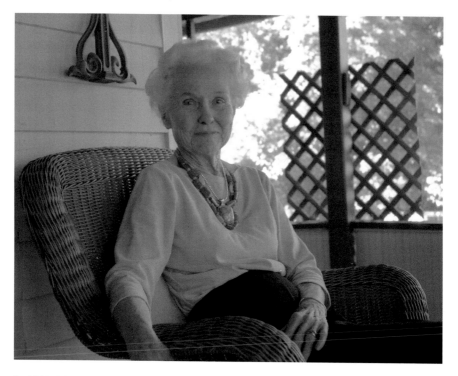

In 2006, Mary Bradford Rovetta sat on the porch of her cottage and reflected on her childhood days in Chautauqua. *Photo by the author.*

Said Rovetta, "The first thing I'd do was go around and touch my favorite rocks." Now in her nineties, she still does. She feels a kinship with author and naturalist Henry David Thoreau, who once wrote, "I love to see and sit on rocks which I have known."

The Chautauqua experience that Rovetta knows and loves so well began as a cultural and educational movement to provide classes, music and entertainment to communities all over the country. Of hundreds of similar Chautauqua communities, Boulder's (at 900 Baseline Road) is one of only three that remain.

Several families, like Rovetta's, came from Bonham, Texas. In the early days, they traveled to Boulder by train. The fathers had to get back to work and could only stay a short time, but the mothers and children stayed all summer.

Although there were art and dancing lessons and other organized activities, the children often made their own fun. When they weren't

climbing to the roof of the auditorium, they'd crawl around under the benches and search through sawdust on the dirt floor for coins that had fallen out of men's pockets.

As Rovetta and her friends got older, they participated in group hikes. In 1934, at a "steak fry" on top of Flagstaff Mountain, a mutual friend introduced Mary Bradford to another Chautauqua summer resident, Charles Rovetta. On their first date, Rovetta and the man who became her husband went to the auditorium to watch the movie *It Happened One Night.* She said she always considered Chautauqua "a great place for romance."

Rovetta's father died when she was eight years old, but her mother brought the family back to Boulder every summer. Then Rovetta returned to the same cottage year after year with her own children. Prior to his retirement, Charles, now deceased, had joined them when he could leave his work.

When asked her plans for the winter, Rovetta said that she'll "hit the ground running." The spry nonagenarian already has her calendar filled with club activities, including a presentation on Chautauqua to a local organization interested in historic preservation.

Rovetta's children and grandchildren have taken over the task of draining the cottage's water pipes and turning off the utilities at the end of the summer season. Next year, everything will be ready for Rovetta's return.

PART II

Activists and Politicians

BRYAN WELL RECEIVED IN BOULDER A CENTURY AGO

When presidential contender William Jennings Bryan stepped off the train in downtown Boulder on July 13, 1899, he was greeted by thousands of well-wishers. Six additional trains brought more people from Fort Collins, the mountain towns and from Denver, temporarily doubling Boulder's population. Stores closed at noon.

"Cheers, yells, handclapping, waving of hats and handkerchiefs, a roar of sound and a seething sea greeted the ear and the eye simultaneously," wrote an enthusiastic newspaper reporter.

Bryan, the Democratic U.S. representative from Nebraska, had run against Republican William McKinley in the 1896 race for president. Although the "silver-tongued orator," as Bryan was called, had lost the race, he was well liked in Boulder County and other mining districts of the West because of his interest in supporting the free and unlimited coinage of both gold and silver.

The crowds lined Bryan's carriage route as he was driven uphill to the auditorium on the Chautauqua grounds. Many people walked from the downtown depot, while others rented horse-drawn hacks or squeezed onto Boulder's new electric streetcars.

Colorado women had recently won the right to vote, and they made up a large part of Bryan's audience. At the beginning of the program, a band

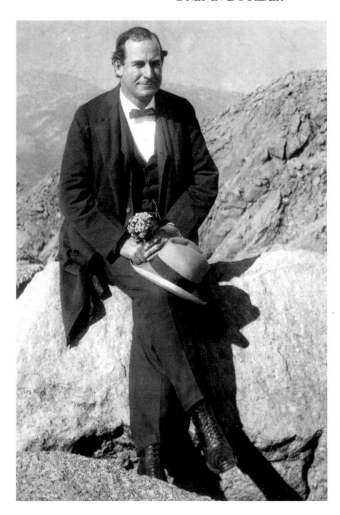

Presidential contender William Jennings Bryan relaxed on a mountaintop during one of his Colorado speaking tours. *Courtesy of the* Daily Camera.

played "Hail to the Chief." When the renowned speaker was introduced as "the next president," men, women and children burst into wild applause.

Bryan's booming voice was said to have reached all of his rapt and patient audience. Rhetorical skill was in vogue and obviously impressed his listeners, who sat through a nearly three-hour speech on "taxation, the money question, trusts, and expansion."

After his oration, Bryan worked his way from the stage to the back of the auditorium and to the overflow of attendees outside, shaking hands with hundreds of admirers. When he reached his carriage, he was immediately driven to the depot, where he boarded the five o'clock train to Denver.

According to the *Boulder Daily Camera*, the day was marred only by the number of pickpockets who combed the audience, despite the efforts of "a noted Denver detective who came over to protect the peoples' pocketbooks in the great Bryan day crush."

In the evening, an enterprising saloon owner renamed his beer "Bryan Beer" and circulated handbills linking the orator's familiar face to his own liquid refreshment. Newspapers called the day "the greatest in the life of the town."

Bryan never did win the presidency, but he left a favorable impression on a majority of Boulder residents, who voted for him in two more presidential elections. In 1925, shortly before he died, Bryan battled attorney Clarence Darrow in the famed John Thomas Scopes "monkey trial." Bryan proved that Scopes had taught evolution in the Tennessee public schools, but in the process, the once-revered speaker was accused by the press of "oratorical flub dub."

Daily Camera editor L.C. Paddock was slightly less critical. When Bryan returned to Boulder and the Chautauqua auditorium in 1905, oratory was still in style. Paddock wrote, "The benches are unthinkably hard. Bryan is the only man who ever rendered them tolerable to the spine, and if he came often we doubt if that hardness that is native to two-inch pine would be entirely dissipated."

EDITH DELONG WAS A SOCIETY GIRL TURNED ACTIVIST

A century ago, Edith DeLong was a popular member of Boulder's literary, music, church and social circles, but the idealistic young woman was more than just a pretty face. The University of Colorado honor student in Greek art and philosophy founded a sorority and then worked for women's rights before illness ended her short but active life.

The DeLong family had moved from Iowa to Boulder in 1888 when Edith's father, Ira DeLong, became a mathematics professor at CU. When Edith reached college age a decade later, there were few associations for women. In her sophomore year, she organized what was called the Alethea Society. Meetings were held in the DeLong home.

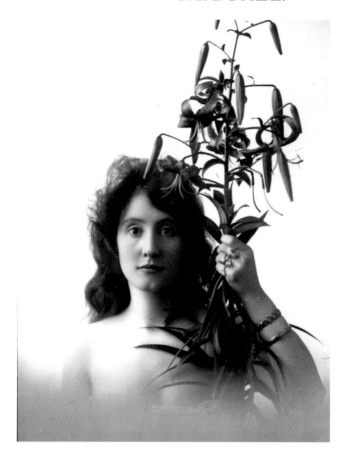

In 1899, Edith DeLong posed like a demigoddess during the formation of the Alethea Society. *Courtesy of the Carnegie Branch Library for Local History, Boulder Historical Society Collection.*

Alethea is a variation of *aletheia*, which in Greek means truth. Its derivations also imply immortality. According to Edith's (possibly initiation) portrait, she appears to have taken on the role of a demigoddess. The eight-woman group became the nucleus of the Beta Mu Chapter of Kappa Kappa Gamma Sorority, which Edith founded the year she graduated, in 1901.

Four years later, Edith married wealthy real estate and mining broker Adolph Jarmuth, and an article titled "Fair Edith Weds" highlighted the society pages of the *Boulder Daily Camera*. Four hundred guests attended what was called "the most beautiful wedding in the history of the city." On the arm of her father, the bride walked down the staircase of the family's large University Hill home while a pianist played Mendlesohn's "Wedding March." The Friday Musical Club sang Lohengrin's "Bridal Chorus," and Edith's sorority sisters chanted the Lord's Prayer.

The new Mrs. Jarmuth was not content, however, to sit back and enjoy a life of leisure. In 1907, Edith and her husband moved to California, where women had not yet been given the right to vote. Edith immediately jumped into a campaign for women's rights.

"While I had always believed in woman suffrage before, I had taken it as a matter of course," she told a reporter. "When I lived in a state where women had no rights, however, the injustice of it dawned more strongly upon me, and I have been working for the cause ever since. I intend to devote all my time to the movement here."

The couple then moved to Seattle, Washington. There, Edith became president of the Washington Women's Suffrage Association and led what the newspapers called "a campaign for the establishment of equality of the sexes at the polls such as Seattle has never seen before."

In 1915, Edith and Adolph Jarmuth divorced. Edith then married Edward Smith and moved to New York City, where her new husband was the editor of the *New York World* magazine. Edith continued to support the women's rights movement and contributed numerous articles on suffrage and other women's social problems.

Edith was ill for a few days in 1919, and then she suddenly died of pneumonia. Her body was returned to her parents' home, where she had celebrated her first wedding. This time, Chopin's "Funeral March" was played on the piano.

No longer immortal, thirty-nine-year-old Edith DeLong Smith was laid to rest at Boulder's Green Mountain Cemetery. She died one year before the Nineteenth Amendment to the Constitution granted suffrage to women nationwide.

DWIGHT AND HER TEMPERANCE WORKERS "RESTED" AT CHAUTAUQUA

When Boulder's Chautauqua opened as a cultural and educational summer resort in 1898, its only buildings were the stark new auditorium and dining hall, both still in use today. The land was barren and without trees, and guests set up housekeeping in canvas tents on wooden platforms. The next year, the association welcomed the summer headquarters of the Colorado

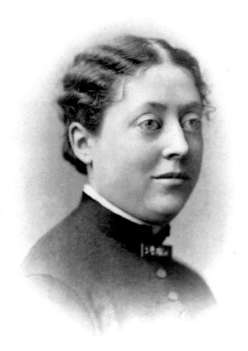

Temperance leader Lena Dwight led women to "agitate, educate, legislate" against the sale and consumption of alcoholic beverages. *Courtesy of the Carnegie Branch Library for Local History, Boulder Historical Society Collection.*

Women's Christian Temperance Union. Members put up a tent that they quickly discovered was hot and uncomfortable.

Temperance worker Lena Dwight was president of the Boulder Chapter of the WCTU and led the way in constructing a "rest cottage" for the alcohol-abstinence crowd. Boulder members contributed most of the $489 needed for furniture and building materials, and Dwight's father, a carpenter, donated his time to turn their dream into a reality.

Of Dwight's campaign to build the rest cottage, the state president of the temperance society wrote:

> *Was Lena discouraged? Not one little bit—*
> *In fact she has never yet learned how to quit.*

On a Sunday afternoon in July 1900, ladies in long skirts and big hats held a brief devotional service and then listened to remarks from local and state

officials, who led them in prayer. Afterward, everyone went in to admire the new two-room building.

According to Dwight's dedication-day notes, the women worked tirelessly "to free dear Colorado from the liquor traffic's strain," and the cottage provided them with a place to rest. Dwight was quick to point out, however, that visitors got more than a cot or a chair. The cottage was a rendezvous for activists, and WCTU literature was available to all who stopped by.

At the dawn of the twentieth century, prohibitionists had steadily gained a foothold in Boulder. Colorado women had been granted the right to vote in 1893, and they were at the forefront of the temperance movement with the slogan "agitate, educate, legislate."

Many sympathetic male voters joined the newly enfranchised women to form the Better Boulder Party, which won most of the Boulder City Council seats in 1907. Teetotaler Isaac T. Earl became Boulder's new mayor, closing down all ten saloons within the city limits.

In July 1910, flush with victory, the temperance ladies again assembled at their cottage for the dedication of a twenty- by twenty-foot addition to their original building.

Recently, the cottage and its addition were restored. Steve Watkins, facilities manager for the Chautauqua Association, along with a crew of five, gutted the building down to its studs, reframed the ceiling and roof, matched old siding and repainted the building in its original off-white and gray.

"It was fun doing research from old photos," said Watkins, who promises to have some on display at an open house. "This was the most unique and most interesting of any of the remodeling projects that I've done."

Although the WCTU is still in existence, its former state headquarters— appropriately retaining the name "rest cottage"—is now owned by the Chautauqua Association and is available for nightly rentals.

Dwight never married and was paralyzed by a stroke during her last year of life. Her obituary writer called her "an inspiration to all." She died in Boulder in 1930 and is resting now, too, at Columbia Cemetery.

SHERWOOD BROUGHT CHICAGO WORKING WOMEN TO BOULDER AND GOLD HILL

Jean Sherwood was an artist, educator and humanitarian. She arrived in Boulder in the early 1900s as an art lecturer and fell in love with the town. Little did she know that she would spend the rest of her life running retreats for working women in both Boulder and nearby Gold Hill. As noted by a *Boulder Daily Camera* reporter at the time, "She thought of the thousands of girls and women, at typewriters, at desks, or teaching in the schools of Chicago whose lives, too, might be blessed by such beauty."

Year after year, Boulder's mountain backdrop pulled her back.

Sherwood organized the Holiday House Association in 1908 and dedicated it to "conserving the health of tired working women." She bought a Boulder city lot near Chautauqua Park and then appealed for money from her artist friends to build a "cottage."

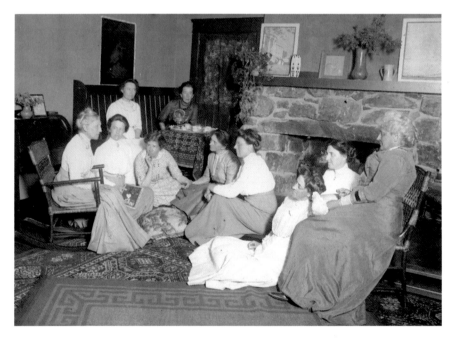

Jean Sherwood, in the chair on the left, opened the Blue Bird Cottage—a Boulder vacation home for single working women from Chicago. *Courtesy of the Carnegie Branch Library for Local History, Boulder Historical Society Collection.*

Ground was broken at 1215 Baseline Road in March 1911. Because Sherwood stumbled on a nest of bluebirds during construction, she called the building the Blue Bird Cottage. Her paying guests became known as "Blue Birds."

At the time, the sixty-five-year-old benefactor was recently widowed and made Boulder her permanent home. That first season, she welcomed forty-one single women.

To join the association, each woman bought a ten-dollar life membership, which entitled her to spend two weeks every summer at the cottage for the rest of her life. The only additional charge was a few dollars per week for food.

In an interview with the *Daily Camera*, Sherwood explained that her retreat was for the benefit of working women who never leave the city from one year's end to another "because they cannot afford to pay the exorbitant rates asked by most so-called summer resorts."

Beginning in 1917, Sherwood welcomed women year-round. Her only rule was to do nothing that would make anyone else uncomfortable. Blue Bird Cottage became "a place of plain living and high thinking."

In 1921, the vacation cottage was so successful that the association bought a hotel building in the mountain town of Gold Hill (west of Boulder) and opened it as the Blue Bird Lodge. Three years later, the association built the dining room next door, now a private restaurant called the Gold Hill Inn.

At the age of seventy-seven, Sherwood founded the Boulder Art Association. Then she organized the Boulder Artists' Guild, but she kept up her interest in the Blue Birds. She built additional houses on Baseline Road between Twelfth and Thirteenth Streets. In Gold Hill, the association spread out into several cabins.

By 1934, 5,400 Chicago working women had vacationed with Sherwood in either Boulder or Gold Hill.

Sherwood died at the Blue Bird Cottage in Boulder in 1938 at the age of ninety-two. Her only child, a daughter, had preceded her in death.

The association continued its retreats until 1958, when the cottage was sold. A *Daily Camera* headline that year read, "Bluebirds Have No Nest." In 1961, the lodge in Gold Hill also passed into private ownership, but it is still called the Blue Bird Lodge today.

CU PRESIDENT FARRAND ALSO SERVED MANKIND

The names of Farrand Hall and Farrand Field at the University of Colorado are familiar to Boulder residents. Both honor Dr. Livingston Farrand, CU's fourth president. The medically trained educator took office on New Year's Day 1914. He stayed long enough to leave his name, but his duties became divided in 1917 when he took a leave of absence to head a medical mission in France.

Wedged between President James H. Baker's twenty-two-year term and George Norlin's twenty-year term, Farrand's tenure was comparatively short. Even though his attentions were divided, he wore both hats well. The *Boulder Daily Camera* called him an "outstanding educator, scientist, and organizer" and praised his World War I–era work as "far-reaching service to mankind."

Born in Newark, New Jersey, in 1867, Farrand graduated from Princeton in 1888 and then received his medical degree from Columbia University. He studied for several years in Europe, including a year each at Cambridge and at the University of Berlin. When he returned to the United States, he joined the psychology department at Columbia and then chaired its anthropology department prior to moving to Boulder to become CU's president.

Farrand was known as warm, friendly and outgoing. He and his wife, Margaret, and their five children, then ages six through twelve, moved into the Presidents' House (now Koenig Alumni Center) on the Boulder campus.

The prewar years were a period of transition for the university. During Farrand's tenure, he was instrumental in winning a ten-year mill levy from the state legislature for capital construction, which paved the way for a unified architectural style on the Boulder campus. Farrand also played a leading role in obtaining a grant to develop the new Denver campus for the CU Medical School.

In 1917, Farrand temporarily moved to Paris to become director of an anti-tuberculosis commission for the International Health Board of the Rockefeller Foundation. In 1917 and 1918, one-third of the faculty and 15 percent of the students also interrupted their careers and studies to enlist in the "war to end all wars," later called World War I. Farrand left George Norlin, professor of Greek, in charge as acting president.

Farrand returned to CU in 1918 to give the commencement address, and then he went back overseas. The following year, Farrand was still officially

University of Colorado president Dr. Livingston Farrand's tenure was short, but he provided far-reaching service to mankind. *Courtesy of the* Daily Camera.

CU's president, while at the same time he directed the work of the American Red Cross during its transition from war to peace.

Instead of returning to CU when his wartime work was done, Farrand accepted the presidency of Cornell University, in Ithaca, New York, where he remained until his retirement in 1937. Meanwhile, Norlin had officially become CU's fifth president and continued in that position for twenty years.

Norlin stepped down in 1939, the year that Farrand died at the age of seventy-two. In his honor, the flag on CU's Old Main was lowered to half-mast. Meanwhile, the writer of Farrand's obituary in the *Daily Camera* stated that the former president was "loved by students, townspeople, and faculty alike" and called the former resident "one of the most distinguished of United States citizens."

CAMPBELL AND McHARG WERE EARLY CIVIC LEADERS

Decades ago, a *Boulder Daily Camera* reporter described Boulder City Council member Ida Campbell as "faithful, sensible and businesslike." Campbell was elected in 1917, the same year that her attorney friend Flora McHarg used her legal training to help draft the city's charter that set up the city manager form of government still in use today.

The two women were civic leaders in Boulder at a time when men still made most of the decisions.

Campbell had moved from Iowa to Boulder with her husband and children in 1904. During World War I, while two of her sons were in the military service, she was involved in war relief activities. At the time, she discovered that she worked well with other people.

When Campbell was elected to the city council, she made a list of Boulder's needs and then worked toward accomplishing them. Of her no-nonsense approach, a reporter wrote, "She doesn't run wild with fads—nor did she talk bonnets when the subject was bridges."

Campbell was an outspoken advocate of parks, baseball grounds, tennis courts, an art building and swimming pools. No doubt she was behind the construction of the large indoor Hygienic Pool, completed in 1923 (and since replaced with Spruce Pool) on the southeast corner of Twenty-first and Spruce Streets.

Flora McHarg, *left*, and Ida Campbell, *right*, were the first women to serve on the Boulder City Council. *Courtesy of the Carnegie Branch Library for Local History, Boulder Historical Society Collection.*

McHarg had moved from Illinois to Boulder with her parents in the 1890s. She attended the University of Colorado, from which she was the second woman to receive a law degree. Her civic involvements were endless, from helping out on hospital boards to working without pay as a member of the Boulder Parks Commission. She was elected to the city council in 1920.

Two years later, while still on the council, McHarg was elected president of the Boulder Woman's Club. During her tenure she planted trees and shrubbery at Chautauqua Park and placed twenty iron benches downtown. Today, a few of these benches are located at Chautauqua, and two remain downtown in front of the Courthouse Annex on Thirteenth Street.

McHarg never had any children of her own, but she founded the Boulder Day Nursery, still in existence on Spruce Street. She also provided playgrounds for children at Chautauqua and was part of the commission that drew up the original laws governing the Colorado Juvenile Court.

Campbell also was involved in the community. At various times in her career, in addition to the Woman's Club, she was active in the Friday Musical Club, the Boulder chapter of the women's sorority PEO and the Colorado

Federation of Woman's Clubs. She also served on the advisory board of the League of Nations Association, Inc., organized to work for the entrance of the United States into the league of the World Court.

After several years of failing health, Campbell died in 1956 and was buried next to her husband at Green Mountain Cemetery. McHarg suffered from crippling arthritis and spent the final thirty years of her life confined to a wheelchair. When she died in Arizona in 1961, the *Daily Camera* noted, "Mrs. McHarg has probably contributed more to the progress of Boulder than any other woman."

ANTOINETTE BIGELOW EARNED RESPECT OF CU WOMEN

In 1910, when Antoinette Bigelow first arrived at the University of Colorado in Boulder to accept the job of dean of women, she wasn't sure what she had been hired to do. So she asked CU president James H. Baker for some direction. He looked her over from head to toe, paused for a few moments and finally told her that the job was whatever she made of it.

The position of dean of women had been created by the regents in 1901. Previous deans, however, had acted like chaperones—unlike Bigelow, who developed a rapport with the coeds and, in return, earned their love and respect.

Bigelow had graduated from Wellesley College and taught in private schools in New York and Boston before earning a master's degree in English literature at Columbia University. Failing health, however, influenced her move to Colorado.

The single middle-aged mother figure was in her early forties when she began her tenure at CU. For the next few years, she lived with the female students in one of two cottages, at the time the only female dormitory facilities on campus. The rooms were few, and the students (and their dean) had to cook their own meals.

Like a friendly aunt, Bigelow encouraged off-campus female students to bring their lunches—and their joys and concerns—to the cottage, where she provided a blazing fire, a pot of tea and rapt attention.

During the following years, Bigelow taught English literature, continued as dean of women and lobbied hard for new student housing, particularly

Antoinette Bigelow was well respected as the University of Colorado's first dean of women. *Courtesy of the author.*

for freshmen women. In 1928, she retired as dean, but she stayed on as an associate professor.

By 1933, her wish for new housing for women finally was underway. The regents had accepted a loan of $550,000 from the Reconstruction Finance Corporation, part of President Franklin D. Roosevelt's New Deal. The dormitory, named Sewall Hall, honored CU's first president, Joseph Sewall, and was completed by the fall of 1934.

All incoming freshman women were required to live in Sewall Hall. The building was designed in the shape of an "H," with four distinct residence units. Bigelow Hall was, and still is, the southwestern portion of the complex.

Bigelow died in 1939 at the age of seventy-one. The pastor of Boulder's First Congregational Church held a graveside service in Gold Hill, where the former dean had a summer home. Her ashes were buried under wildflowers in an aspen grove in the town's small mountain cemetery. A flat engraved stone still marks the spot today.

Three more deans of women oversaw the university women's needs in the years to come, ending with Pauline Parish, who served in the 1960s. Afterward, the former dean of women's position was combined with that of the former dean of men into the dean of students. Reflecting changes in society, the university no longer parented its students, and both women and men were encouraged to learn to live on their own.

During her time, Bigelow filled a need in the lives of female students. Besides protecting them, she empowered them. Maybe that's what President Baker had in mind all along.

RUTH CAVE FLOWERS WAS AN ADVOCATE FOR HUMAN RIGHTS

When Ruth Cave Flowers completed high school in Boulder in 1920, her high school principal refused to give her a diploma because of her race. Even so, she was admitted to the University of Colorado, from which she graduated in 1924. Many years later, in 1977, Flowers gave the commencement address at Boulder High School and was surprised with a diploma in her name—more than a half-century overdue.

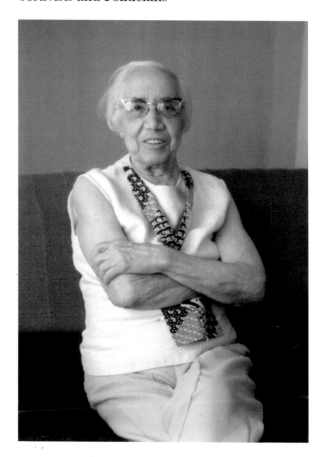

Ruth Cave Flowers, an accomplished educator, advocated for human rights. *Courtesy of the Carnegie Branch Library for Local History, Boulder Historical Society Collection.*

Flowers once told an interviewer that all she asked was just to be considered another human being. Growing up in Boulder wasn't easy for an African American woman, but she persevered and was showered with accolades during her eventual teaching career.

Born in Colorado Springs, the young girl was abandoned by her father and orphaned, at age eleven, by her mother. Flowers and her sister then moved to Cripple Creek to live with their grandmother. A few years later, in 1917, they all moved to Boulder, hoping for better educational opportunities.

At the time, most members of Boulder's African American community lived in the flood-prone area of town known as the "little rectangle," an area bounded by Canyon Boulevard and Goss, Nineteenth and Twenty-third Streets. There, at 2019 Goss Street, the family built their home, now a Boulder city landmark.

Flowers enrolled in the State Preparatory School (forerunner of Boulder High School) while she worked in a laundry and washed dishes in a restaurant in order to support herself, her sister and their grandmother. Even without the diploma, she had completed the required high school credits and was admitted to CU, where she became a foreign language major.

At the university, she was allowed access to her classes but was denied food service on campus. President George Norlin (who defied the Ku Klux Klan) heard of her determination to stay in school and provided her with a job. He also taught Greek and may have inspired her love for the classics that she retained throughout her career.

After graduation, and fired with ambition to become an educator, Flowers moved to Washington, D.C., where she earned a doctoral degree in Romance languages. She also earned a law degree, married a lawyer and, for a time, practiced law—but she preferred teaching. She became a language professor in colleges in both North and South Carolina.

In 1959, Flowers returned to Boulder and taught Spanish and Latin at Fairview High School. She was the first African American teacher in the Boulder Valley School District. Ten years later, Harvard University selected her as one of four outstanding teachers in America.

Former colleague and past state legislator Dorothy Rupert spoke of Flowers's "infectious love of learning" and her "strength, gentleness and clear intellect."

When Flowers died in 1980, she had seen a lot of changes during her lifetime. But they weren't enough. She once stated, "I really want to see a time when we won't have to be concerned with black awareness, brown awareness, women's rights or whatever, but simply human rights and human awareness."

ANNA BELLE MORRIS DEVOTED HER LIFE TO ANIMALS

Anna Belle Morris was educated as a teacher, but she gave up a paying job to devote her life to the welfare of animals. She founded and nurtured the Boulder Humane Society, making it her life's work. At the time of her death, she was eulogized for a "career of kindness."

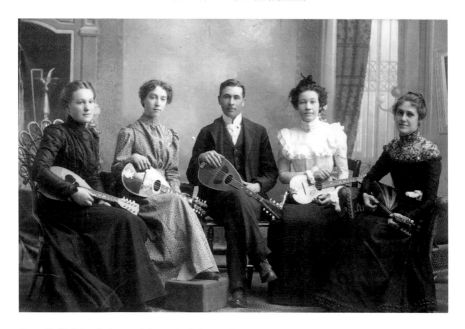

Anna Belle Morris (second from the left) was known for her kindness toward animals, but she also played the mandolin. *Courtesy of the* Daily Camera.

After earning a master's degree from the University of Colorado, Morris taught from 1925 to 1930 at the Boulder Business College. At the beginning of the Great Depression, she was a typing teacher at North Side Intermediate School (now Casey Middle School), but she soon resigned so that another woman could have her job.

"There are many girls who need to earn their living by teaching," she told a *Boulder Daily Camera* reporter at the time. "I have enough to live on, and I can find plenty of good ways to take up my time, doing things for which I will not be paid."

Her interest in volunteerism came at the right time. In 1931, former Boulder resident Kate Harbeck bequeathed $50,000 to the humane society. A few years later, the organization opened its first animal shelter northeast of Arapahoe Avenue and Forty-eighth Street. Morris was the society's president and traveled widely as its representative and spokeswoman.

In 1947, she attended the National Convention of the American Humane Society in Albany, New York, where she was elected an honorary vice-president. After another convention, in Los Angeles in 1950, she wrote of the

Hollywood entertainment that included Roy Rogers and his horse Trigger, Frank Weatherwax and his dog Lassie, Francis the army mule, Bongo the chimp and Grauman's Chinese Theatre.

Morris even received the coveted Fido Award, which in the humane society world was equivalent to an Oscar for a motion picture. Morris was the first woman ever to receive the award, a bronze statue of a dog on an ebony base. After a tour of California shelters, she returned on the train to Boulder and wrote, "Our Boulder shelter looked good to the writer. It stands comparison nicely."

In 1956, Morris again was honored by the American Humane Society. Robert J. Chenoweth, chairman of the national association, came to Boulder from Washington, D.C., to present her with an illuminated scroll. It had been authorized at the group's last annual meeting, but Morris had been unable to attend. The scroll praised her as the first charter member of the National (American) Humane Society and a leader in humane work. She had also been a member of its Rocky Mountain Regional Advisory Committee.

Whenever the pet shelter needed funds, Morris contributed money out of her own pocket. She died in 1959 at the age of seventy-nine and is buried at Green Mountain Cemetery next to her mother. Morris had never married, and she left her entire estate to local and national humane societies.

In her obituary, a *Daily Camera* writer stated, "She was a gentle little woman, more concerned with what she could put into life than what she could take out of it. She grew rich in the rewards money can't buy and left the community better than she found it."

PART III

Public Servants

LETTER CARRIER "JOE" KEPT ON WALKING

Theophilus Ardourel—better known as "Joe"—was a familiar figure on the streets of Boulder. He once told a reporter that he had walked around the world seven times. He hadn't really, but he claimed to have covered an equal distance in his lengthy carrier as a Boulder "letter carrier."

Ardourel came to Boulder from France as a three-year-old with his parents in 1875. He started working for the U.S. Postal Service in 1898, the first year of mail delivery for Boulder residents. (Before then, residents had to pick up their mail at the post office.)

At the beginning of Ardourel's career, Boulder was a city of approximately six thousand people, and the unpaved streets were either muddy or dusty. In the early years, Ardourel drove from house to house in a wagon pulled by his horse, Maude. Residents were instructed to place their mailboxes where the carrier could reach them without getting out of his buggy.

Residents tacked red cloths inside their mail boxes and then pulled out the cloths when they had letters for Ardourel to pick up. He also had a supply of stamps and postcards available for purchase by his customers.

Maude was put out to pasture in 1917. Ardourel then took a stint inside the post office before beginning his "foot" route, on which he averaged twelve to fourteen miles per day. Rarely did he miss a day of work. In a 1930

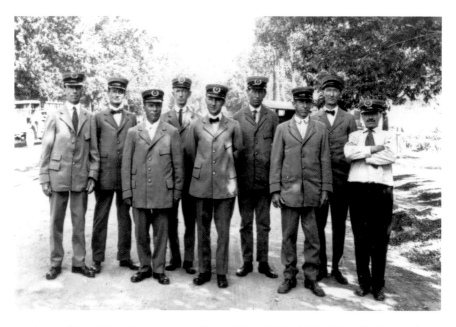

Joe Ardourel (far right, with arms crossed) posed circa 1910 with his fellow Boulder mail carriers. *Courtesy of the Carnegie Branch Library for Local History, Boulder Historical Society Collection.*

interview, the fifty-nine-year-old stated, "I'm confident that walking in the open air every day has been the reason for my fine health."

At the time, paved sidewalks had made the carriers' routes easier to cover, but the bulkiness of the mail slowed them down. Boulder's population had swelled to eleven thousand, and the type of mail had changed.

"Nowadays, the mail is much heavier, and carriers must have shorter routes to get it all delivered," Ardourel stated. "My route to Maxwell, Mapleton, Concord, Dewey, Portland, Ninth and parts of Twelfth [now Broadway] Streets is small compared to the routes in the old days."

"Tons of magazines" were added each year to the normal delivery of postcards, letters and catalogues. In Ardourel's interview, he was described as "the picture of health, tanned, with eyes as clear as youth's, and with a complexion that refuses to acknowledge Father Time."

Ardourel's children did not inherit their father's fondness for walking. Sons Joe and James ran Ardourel's Super Service gas station on the southeast corner of Eleventh and Pearl Streets, now Old Chicago Restaurant. Alphonse ran the Independent Taxi Company, and Clement was a motorman on a

bus. In 1931, the four sons and a daughter surprised their mother, Elizabeth, with a brand-new automobile.

After serving for thirty-five years, the senior Ardourel was named the first carrier to receive a new government pension. When he retired in September 1933, fellow carriers and their families came to his home and serenaded him with the song "Blest Be the Tie that Binds."

Even in retirement, though, he wasn't tied down. His wife had her car, but Ardourel just kept on walking.

EBEN G. FINE WAS BOULDER'S BIGGEST PROMOTER

In 1922, when Boulder pharmacist Eben G. Fine attended a convention in Dallas, Texas, he was asked to give a presentation at a closing banquet. Instead of talking about his profession, he showed hand-colored lantern slides of the Boulder area. A representative of the Burlington Railroad told Fine that his illustrated lecture would encourage more people to travel to Colorado than any advertising the railroad company could do.

At a time when Boulder residents wanted their city to grow, Fine took the advice to heart. He became the city's biggest promoter, earning him the nickname "Mr. Boulder."

Fine was born in 1865 as one of twelve children in a farm family in Missouri. He moved to Boulder in 1886 and got a job in Fonda's Drug Store on Pearl Street. Three years later, he married the store owner's sister, Mary Coulson, who had a son, Hal Coulson.

Between 1907 and 1925, Fine and his stepson worked as pharmacists at the Temple Drug Store in the Masonic Temple Building, then located on the southwest corner of Pearl and Fourteenth Streets.

Meanwhile, Fine had taken up photography as a hobby, stating at one time that it was his way of keeping up an interest in the outdoors whenever he could get away from the store.

He joined several climbing clubs and lugged his heavy large-format camera with glass-plate negatives into the mountains, writing in his autobiography that he "tried to express nature in her various moods." Fine got his stepson interested in photography, as well, and the two men took and sold photographs under the "Fine & Coulson" imprint.

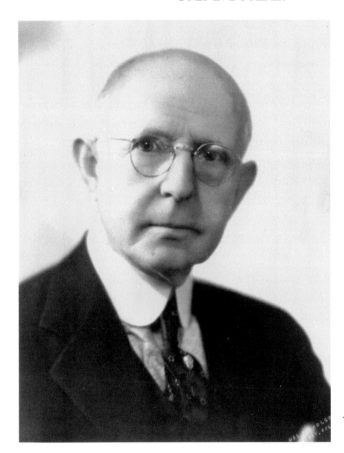

Eben G. Fine, known as "Mr. Boulder," traveled around the country to encourage people to visit the city. *Courtesy of the Carnegie Branch Library for Local History, Boulder Historical Society Collection.*

With a large collection of photographs, and Coulson in charge of the store, Fine then partnered with the railroad company and traveled by train, for free, mostly to the South and Midwest. In his promotional literature, he called himself a "nature lover, traveler, photographer, and lecturer of Boulder, Colorado." His *Rambles Through the Rockies* travelogue was described as "a sermon, a poem, and an art exhibit."

For fourteen years, Fine's two-month-long-annual tours brought him in front of more than 3,500 audiences, including university, church and service groups. He never missed an opportunity to extol the beauties of Boulder and the surrounding area. A newspaper reporter explained that although the presentation advertised all of Colorado, Fine arranged his slides "to leave Boulder indelibly impressed upon the minds of the audience."

In 1927, while keeping up his travels, Fine retired from his profession as a pharmacist and was elected secretary of the Boulder Chamber of Commerce, a position he held for many years.

Fine died on April 30, 1957, at the age of ninety-one, after falling out of a second-story window at his home. He was buried with his family at Columbia Cemetery. Eben G. Fine Park, at Arapahoe Avenue and Third Street, was dedicated in his memory in August 1959.

After Fine's death, *Boulder Daily Camera* editorial writer James Corriell stated, "The life he lived was one so richly filled with service that it scarcely seems that 'Mr. Boulder' has left us. The cargo of good he did far outweighs the burden of grief we bear at his departure."

SHERIFF EVERSON'S FAMILY MADE THE COURTHOUSE THEIR HOME

Arthur T. Everson became Boulder County sheriff in 1943, and room and board came with the job. But there was a trade-off—his wife, Dorothy, had to cook for the prisoners. Their cells, as well as an apartment for the Everson family, were located on the fifth floor of the Boulder County Courthouse.

Daughter Shirley Everson, now Longmont resident Shirley Rink, was in sixth grade when the family moved in, and she remembered that her mother made it "real homey."

Shirley and her younger brother, Bob, each had rooms of their own in the clock tower. They could climb out onto the roof, where their father had created a makeshift yard for the family's pet terrier. He also strung a clothesline for their mother's weekly wash.

Life in the sheriff's home revolved around mealtimes. For years, Dorothy prepared all the meals for the prisoners and for her family, and they all ate the same food.

In the morning, the children would get fresh rolls at the Boulder City Bakery, go to school and then return home at noon for the main meal of the day. Often it consisted of meatloaf or roast beef with vegetables and salad. Desserts were homemade coconut cakes and cherry pies. Supper, in the evening, consisted of a light meal or sandwiches.

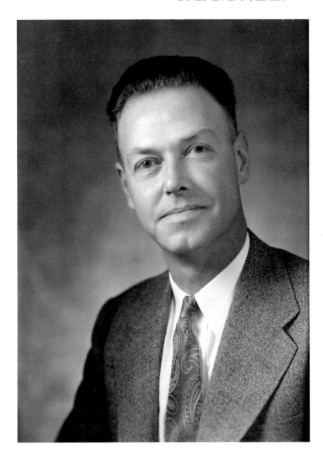

Sheriff Art Everson
and his family lived in
the Boulder County
Courthouse for twelve
years. *Courtesy of the* Daily
Camera.

The thirty or so prisoners were either locked in their cells or in a common area. Shirley took food to the women, sliding trays through a door, just like it's done in old movies.

According to Shirley, her parents didn't want to make life too hard or too easy for the prisoners. Dorothy donated magazines for the women to read, as well as materials for knitting and crocheting. Art lent the men a radio to listen to the World Series baseball games.

Grocery shopping and dishwashing took up most of the rest of the day. Shirley and her mother often made their rounds to markets to purchase meat and produce in bulk. During World War II, they spent a lot of time at the ration board, trying to get sugar.

In 1949, the year Shirley graduated from high school, a *Boulder Daily Camera* reporter quoted her mother as saying that the family "lived like fish

in a goldfish bowl." This was particularly true when the courthouse was decorated for Christmas. Speakers projected holiday songs from records that Bob changed in his bedroom.

Santa Claus kicked off the shopping season with his annual pre-Christmas downtown visit. Unknown to the waiting children and parents below, he would change his clothes in the Eversons' apartment. Suddenly, a spotlight would discover Santa on the roof. Without a chimney to descend, he took the elevator to the first floor and emerged to enthusiastic crowds.

Even Christmas brought no respite from hungry prisoners. For Christmas dinner, the Eversons invited twenty relatives, and everyone—family and prisoners alike—ate the same turkey with all the trimmings.

Finally, in 1955, after living in the courthouse for twelve years, the Eversons moved out. Another family moved in and cooked until 1961, when the prisoners were transferred to a jail in the newly built west wing of the courthouse.

Shirley remembers her mother simply saying, "Enough is enough."

Johnson Prepared Residents for Survival

During the Cold War of the 1950s, experts speculated that if the Soviets were to drop a hydrogen bomb on the Rocky Flats Atomic Weapons Plant (south of Boulder), the Boulder area would experience widespread death and destruction. In the fall of 1956, the City and County of Boulder created a Civil Defense Agency with a dual role—to act as a deterrent and to prepare the public for possible evacuation.

Boulder residents had their bags packed, and former civil defense director Stanley F. Johnson made sure that they knew what to do. "Psychologically, the plan was very significant," he said in a recent interview. "It gave the people hope that they could survive."

Johnson, along with the police chief and the sheriff, determined that if a twenty-megaton bomb landed squarely on the Rocky Flats plant, Boulder could be completely destroyed and everyone could be killed. If the bomb fell closer to Denver, some Boulder-area residents would survive.

Regardless of what area was targeted, warning of an imminent attack would set off sirens that would blast steadily for five minutes. Radio and

Stanley F. Johnson, shown here in the 1960s, directed Boulder's city and county Civil Defense Agency during the Cold War. *Courtesy of the* Daily Camera.

television stations were set to switch to "Conelrad," the civil defense emergency radio network. Schoolchildren would be moved to evacuation centers, where their parents would be instructed to pick them up.

Johnson and his fellow authorities divided Boulder and Boulder County into different zones with different evacuation routes and destinations. Residents in the "A area," south of Arapahoe Avenue, would drive east on Arapahoe and then north on U.S. 287, ending up in Greeley.

University of Colorado personnel and students, however, would (in pre–Diagonal Highway days) follow back roads to Loveland and go west through Big Thompson Canyon to Estes Park. The "B area," north of Arapahoe Avenue and west of Nineteenth Street, would also go in that same direction.

The "C area," north of Arapahoe Avenue and west of Nineteenth Street, would go north on U.S. 36 through Lyons to Big Elk Meadows in North St. Vrain Canyon.

Civil defense workers would be headquartered at Blanchard's Lodge (now the Red Lion Inn) in Boulder Canyon. Pedestrians were instructed to walk in the direction of Boulder Canyon, where emergency vehicles would take them to Nederland. Fallout was expected to blow to the east, so mountain residents were told to stay where they were.

All residents were expected to always keep more than a half-tank of gas in their cars. They were also told to carry (at all times) a first-aid kit, a flashlight, blankets, a radio, a shovel, toilet paper, prescription drugs and medications, fresh water and nonperishable food. Field kitchens would be set up to feed the evacuees until it was deemed safe for them to return home. No one knew how long they would be gone or what the effects the bomb would have.

As civil defense organizer and educator, Johnson (who later became Boulder district attorney and a state legislator) compared his role to that of a needle in that he took the threads and sewed everything together. "I'm glad we never had to try it, but if we had, we would have had survivors to carry on," he said. "Figure the math."

FATHER FIFE WAS A CATHOLIC PRIEST AND A COLORFUL CHARACTER

From 1943 to 1956, Father Paul Fife was the colorful and occasionally impatient pastor of the Sacred Heart of Jesus Catholic Church in Boulder. He was often seen walking between the church, school and the rectory (where he lived) wearing a smoking jacket, puffing on his pipe and followed by Polly, his pet parrot.

A native of Pennsylvania, Fife had joined a band of Benedictine monks who moved to Colorado to establish the Holy Cross Abbey in Cañon City, Colorado. Fife was the first of the Benedictines from the Abbey to be ordained as a priest. He served various Colorado parishes for twenty-one years prior to 1943, when at the age of forty-eight he accepted a position in Boulder.

At the time, the Sacred Heart Church was located in its former church building on the northwest corner of Mapleton Avenue and Fourteenth

Father Paul Fife posed for this photograph shortly after he left the Sacred Heart of Jesus Catholic Church. *Courtesy of the* Daily Camera.

Street. (The building was razed prior to 1963 and replaced with the current Sacred Heart Church on the southwest corner of the intersection. A parking lot now covers the site of the former church building.)

A *Boulder Daily Camera* story from 1953 stated that Boulder residents looked forward to meeting Fife and Polly on the street. The thirty-seven-year-old South American bird didn't like to be carried and would waddle after Fife or his housekeeper, Esther Christy. Often, Polly would follow Christy when she did her grocery shopping in downtown Boulder.

Polly had a vocabulary that included fifty words, as well as a raucous laugh, blood-curdling groans and wolf whistles. She also had a voracious appetite

and consumed quantities of spaghetti, cereal, toast, potatoes, chicken and steak bones. Her favorite food was tutti-frutti ice cream, which she ate with a spoon clutched with her left talons.

Fife's pet must have been nearby when the Sacred Heart Church honored him with a large reception on the anniversary of his twenty-fifth year in the priesthood. After a solemn High Mass, the honored guest shook hands with three hundred well-wishers.

Children from the Sacred Heart School presented him with four roses—in bud, half-open, open and in full bloom—and then recited Bible verses applicable to different periods of Fife's life. Church members generously contributed to a fund that he used the following summer for a European trip that included an audience with Pope Pius XII at the Vatican.

Former Boulder resident Ron Quintelier, who was a Sacred Heart student and an altar boy at the church, remembers Fife as a man with little patience. "When hearing a confession," said Quintelier, "Father Paul would frequently cut you short if you pondered your words too long while confessing your sins."

In 1956, illness forced Fife's retirement from the Sacred Heart of Jesus Church, and he was replaced by Reverend Edward Vollmer. Fife moved to Pueblo where, five years later, he died of a heart attack at the age of sixty-five. He's buried at the Holy Cross Abbey, where he had begun his long Colorado career with the Catholic church.

No records have been found to explain what happened to Polly.

DOCK TEEGARDEN'S LOVE OF THE WEST SPANNED NINE DECADES

In 1984, at the age of sixty-five, Dorse "Dock" Teegarden suffered a heart attack. When he recovered, his doctor told him that he had to walk two miles a day. Instead of hitting the sidewalks around his south Boulder home, he headed for the open lands he had known and loved all his life.

The walking gave Dock a new lease on life—a long life that spanned nine decades of Boulder history. He died on December 11, 2009, at the age of ninety.

"I've been something of a romanticist and always had an interest in the West," he told me, several years ago. "Sometimes I feel I was born fifty years too late. I would have liked to have seen the buffalo."

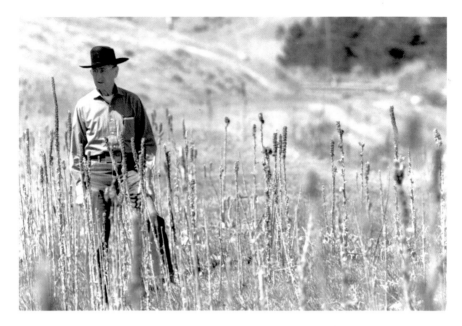

Dock Teegarden was photographed in 1998 on one of his walks on Boulder County Open Space property. *Courtesy of the* Daily Camera.

Born in Boulder in 1919, Dock was a Depression-era kid who grew up exploring the foothills. Although he had friends his own age, he preferred spending time with older people. He said that the old-timers tolerated him, took him hunting and fishing and made life a lot more interesting.

Dock's father, Myron Teegarden, was a plumber but joined the Boulder Police Department after being out of work. Myron climbed the ladder to become police chief, taking office in 1949.

By then, Dock had served in the Army Air Corps during World War II. Upon his return to Boulder in the summer of 1945, he took a job with the Boulder County Sheriff's Office. At first, he worked the crowds at the Boulder Pow Wow Rodeo, and then he assisted Identification Officer Ed Tangen.

Law enforcement became a big part of the lives of both father and son. Myron, along with Sheriff Art Everson, started what was called the Boulder Crime School. In annual weeklong training sessions, officers from Colorado and surrounding states were taught the latest techniques in crime scene investigation.

In the early 1950s, these classes included identification of evidence, blood and fingerprint collections and ballistics and gunpowder tests, as well as analysis of hair, fiber, handwriting and typewriting specimens. Class members also learned to organize, chart, draw and photograph crime scenes. As a deputy, Dock attended the classes, and he also served as Boulder County's undersheriff from 1953 to 1955. Afterward, he was hired by the U.S. Postal Service and worked for many years at the main post office and then at the Hi Mar Station. (Myron remained police chief until 1967.)

During Dock's retirement, and after his heart attack, he worked as a City of Boulder Open Space Department volunteer, committed not only to protecting the land but also to preserving its past. Everything interested him, from weeds and wildlife to Indian artifacts and the still visible routes of stagecoaches and railroads.

During this time, Dock also volunteered at the Sheriff's Office, providing assistance with its firearms program and reviewing cold case files. At least two days a week, however, he could be found repairing fences, hanging signs, measuring trails, chasing cows or documenting newly discovered historic sites.

One of his tasks was to hike with new trail guides. "If they're interested and asking questions, then I have the time," he stated. "I'm proud of this country, damn it, and I feel like passing on some of the heritage."

PART IV

Artists and Photographers

MARTHA MAXWELL WON NATIONAL ACCLAIM FOR HER ANIMAL DISPLAYS

In 1874, Boulder was a frontier town of fewer than three thousand people, but its lack of sophistication didn't detract the locals' interest in the Rocky Mountain Museum. Located in a (no longer standing) brick building on the northeast corner of Pearl and Twelfth (now Broadway) Streets, the museum's exhibits included fauna, fossils, minerals and other collectibles. All were overshadowed, however, by pioneer naturalist Martha Maxwell's dioramas of native animals that she *herself* shot, stuffed and displayed.

The *Boulder County News* reported on what soon became known as the Martha Maxwell Museum. All of the collections were owned by the then forty-three-year-old petite female taxidermist. On the museum's opening day, visitors arrived to the music of the Boulder Brass Band. According to a reporter, Maxwell's meticulously displayed collections included "everything in air, sea, earth, or under the earth, imaginable."

Maxwell was a pioneer in her field and quickly became known for immortalizing animals in lifelike settings—a novelty for the nineteenth-century visitors. Commented the reporter, "The artificial rock work and grotto in the rear are fairly swarming with animal specimens in the most natural positioning."

Author Helen Hunt Jackson also visited the museum. In her book *Bits of Travel at Home*, she wrote that she expected to see "corpse-like" animals.

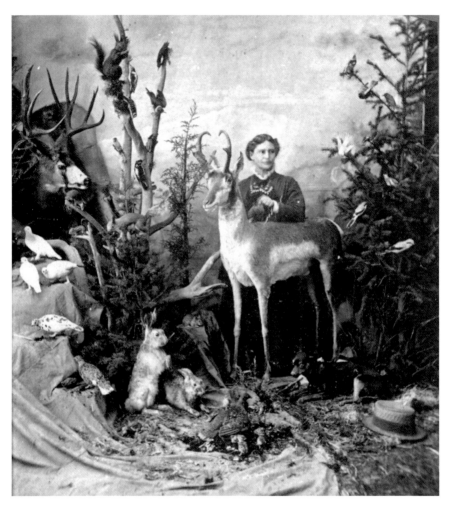

Boulder naturalist Martha Maxwell, known as the "Colorado Huntress," posed in one of her dioramas in 1876. *Courtesy of the Carnegie Branch Library for Local History, Boulder Historical Society Collection.*

Instead, she was impressed by the realism of the displays. Jackson stated that she viewed a stuffed deer standing by a table "in as easy and natural a position as if he had just walked in."

Other collections included a variety of coins and bank notes, gold and silver from Boulder County mines, novelties from China (complete with a shoe from the foot of a "Chinese belle") and a German Bible from 1560. A favorite of the newspaper reporter was an original copy of the Ulster

County, New York *Gazette*, from January 1800, with extensive articles on the death and burial of U.S. president George Washington.

In 1876, Maxwell moved her museum to Denver. That same year, she also displayed some of her dioramas at the country's Centennial Exposition in Philadelphia. There, she stood quietly with her gun at her side behind a modest sign that read "Woman's Work." Lines of people formed early each morning to witness her artistic groupings of stuffed birds and mammals. Illustrated scenes were reproduced in *Harper's Weekly* and other national publications.

Maxwell also was taken seriously by the scientific community. She was credited with the discovery of the Rocky Mountain Screech Owl, which the Smithsonian Institution named in her honor as *Scops maxwelliae.*

Dignitaries at the Centennial Exposition honored Maxwell in a special ceremony. According to the *Boulder County News,* one of Colorado's representatives presented Maxwell with a rifle that held thirty-four cartridges. "I am proud that I am from Colorado," said the speaker. "This [rifle] is not for Mrs. Maxwell, but for Colorado. In honoring her, you honor Colorado. She is a little woman, but she shoots."

Five years later, in 1881, Maxwell developed an ovarian tumor and died in New Jersey in her daughter's arms. The "Colorado Huntress," as Maxwell was called, was only forty-nine years old.

PHOTOGRAPHER "ROCKY MOUNTAIN JOE" LEFT A LEGACY

Joseph Bevier Sturtevant was a familiar figure in early Boulder. From the mid-1880s until his death in 1910, he walked around town with seventy-five pounds of photographic equipment on his shoulders. He took pictures of nearly every place and every event worth recording. More commonly known as "Rocky Mountain Joe," he was Boulder's most prolific photographer and one of its most colorful characters.

With long hair, mustache, goatee, sombrero and fringed buckskin shirt and pants, Sturtevant dressed like the Indian scout he claimed to have been. Children often followed him to the top of Flagstaff Mountain, where he built campfires and held his youthful audiences spellbound with stories of his exploits.

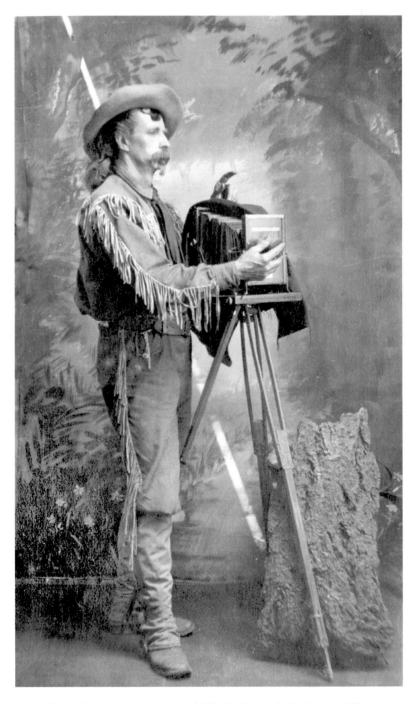

Joseph Bevier Sturtevant, also known as "Rocky Mountain Joe," dressed like an Indian scout and was Boulder's most prolific photographer. *Courtesy of the Carnegie Branch Library for Local History, Boulder Historical Society Collection.*

Over time, his tales became exaggerated, but they included fighting under George Armstrong Custer and a dozen different generals, killing Indians and escaping from a stake on which he was about to be burned.

Sturtevant also had a way with the ladies. Often he would take a stagecoach filled with tourists for a drive in the mountains. He made a point of learning the names of the young women on his tour. If, for instance, one was named Mary, he would point with a flourish to a mountain and say, "There is Mount Mary."

Born in Boston, Massachusetts, Sturtevant grew up in Wisconsin, where his father had become an Indian trader. Legendary accounts state that as a youngster he befriended some Indians, who taught him to ride and shoot. Eventually, he performed in a traveling circus until he joined the U.S. Army.

After his stint in the military, Sturtevant moved to Boulder. Still in his twenties, he first earned a living as an artist. He hung wallpaper and painted houses, signs and theatre scenery. By 1884, he had turned his talents to photography.

His first wife, Anna, and their children helped him with his business. The family sold mounted cabinet-sized $3\frac{7}{8}''$ by $5\frac{1}{2}''$ photographs of Boulder scenes for ten cents apiece, even though other photographers complained that he undercut their prices. He had several studio locations, but at least two were named "The Cabinet" because of his specialty.

After Anna died, Sturtevant took to the bottle. He found a new bride, but the marriage didn't last. He started, but never finished, an illustrated book of poetry titled *Sparkling Gems of the Rocky Mountains*. His topics were humorous as well as sentimental, and he always displayed his deep affection for Boulder. Toward the end of his life, a newspaper account stated that he fell from some high rocks, was nearly gored to death by a deer and had "many other little accidents which give spice to life."

In 1910, Sturtevant was found dead on the railroad tracks between Denver and Boulder. It was assumed that he didn't have the fare for the Interurban Railroad and fell as he tried to jump onto a moving train.

During his twenty-six years as a Boulder photographer, Sturtevant took thousands of photographs, which today offer our best visual link to the city's past. Despite his tragic end, his legacy lives on.

PHOTOGRAPHY WAS ONE OF LOUIS MEILE'S SEVERAL TRADES

When the "100-year flood" ravaged Boulder in 1894, Louis Meile (pronounced MY-lee by the family) captured the scene with his camera. He was in partnership, at the time, with the more well-known photographer Joseph Sturtevant, but Boulder Creek separated Sturtevant from his camera. Whether fate intervened, or Meile just got lucky, he continued for several years on his own.

Although Meile's portraits and Boulder scenes are still sharp and clear today, photography was only one of his trades.

After his split with Sturtevant, Meile moved into a studio in a small building (no longer standing) across Pearl Street from the *Boulder Daily Camera* office. He and his wife, Margaret, sold portraits and Boulder scenes for several years.

Their granddaughter, Pauline Meile Cleveland, was born in the Meile home at Sixth Street and University Avenue in 1914. By then, Meile had given up professional photography. At some point in his life, he painted decorative designs on farm wagons and worked as a blacksmith.

"He'd tell me stories for hours," Cleveland said. "I only wished I had listened more at the time. He was kind, and I remember his big mustache."

Cleveland also remembers listening to her grandfather talk about taking his sons (her father and uncle) on photography trips into the mountains. His horse-drawn "photography wagon" carried his bulky camera, tripod, developing chemicals and glass-plate negatives.

In the early 1900s, Meile operated a gold mine near the town of Sunshine, west of Boulder. Even though he was no longer listed as a photographer in the *Colorado Business Directory*, he continued to take photos, including several of family members enjoying their mountain cabin at the mine.

In 1918, when Cleveland was four years old, she moved with her parents to a farm in Haxtun, in eastern Colorado. Louis and Margaret Meile maintained their home in Boulder but spent the summers with the family in Haxtun, where Meile kept a team of horses named Nell and Bell.

"One time there was a hailstorm, and most of the men took cover," said Cleveland. "Even though my grandfather got beaten up by the hail, he stayed and talked with his horses until the storm had passed. He loved animals. You didn't hardly kill a bug around him."

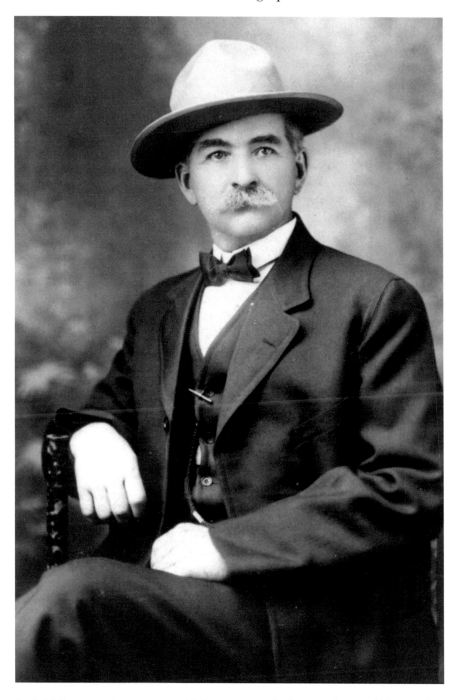

Louis Meile, at one time a partner with Sturtevant, made photography one of his several trades. *Courtesy of the author.*

Cleveland moved back to Boulder circa 1930. She often visited with her grandfather in his west Boulder neighborhood, where by that time he raised raspberries, blackberries and strawberries.

Photograph collectors who've done their research know that photos signed "Meile and Sturtevant" date from 1893 and 1894, during the pre-flood years when the two photographers were in business together. According to family legend, however, some photos signed "Sturtevant" may have actually been taken by Meile, as his competitor was said to have removed his name on some of the photos taken during their partnership.

Meile was a longtime Boulder photographer, painter, blacksmith, miner, farmer and fruit grower. He died at the age of seventy-seven in 1935 and is buried a few blocks from his home, at Columbia Cemetery.

His old partner, Sturtevant, is there, too.

MATILDA VANDERPOEL WAS AT HOME IN GOLD HILL

Matilda Vanderpoel was an accomplished artist who specialized in pastel portraits, landscapes and flowers. Between 1909 and 1923, she taught and exhibited at the Art Institute of Chicago, at which her brother, John, was the director. But her heart was in Boulder County, particularly the town of Gold Hill.

Vanderpoel was born in Holland and came to the United States as a child. She first visited Boulder when she was thirty-seven years old, arriving in 1898 to accept the position of art instructor at Chautauqua during the educational and cultural resort's opening year.

As director of the Department of Drawing and Painting, Vanderpoel gave lessons in pastels, charcoal, pencil, watercolors, oil paints and pen and ink. She included adults in some of her classes, but teaching children became her specialty.

She taught her students to make still-life sketches of plants, fruit and flowers, as well as to pose for one another for life drawings. Tuition was five dollars for twelve lessons.

During her time at Chautauqua, Vanderpoel met artist Jean Sherwood. In 1908, Vanderpoel assisted Sherwood in organizing the Holiday House Association, dedicated to "conserving the health of tired working women."

Artist Matilda Vanderpoel, photographed here in Chicago, spent much of her time in Gold Hill. *Courtesy of the author.*

The association built a house at 1215 Baseline Road, close to the Chautauqua grounds. The house was called the Blue Bird Cottage for a nest of bluebirds disturbed during construction. Vanderpoel painted wall murals over the fireplaces in the living and dining rooms.

In 1921, the association expanded into Gold Hill. The mountain town had been settled by gold prospectors in 1859, and its only hotel, the Wentworth, was built in the 1870s. The association converted it into the Blue Bird Lodge, where Chicago women vacationed for the next four decades.

Vanderpoel fell in love with the then quiet former gold mining town. Instead of returning to Chicago full time or staying at the cottage in Boulder, she made Gold Hill her summer home.

Two years later, with her brother, Cornelius, and his wife, Marie, Vanderpoel moved into a house named Sunset View on the northeast corner of the intersection of Boulder County Roads 52 and 89. Shortly afterward, Vanderpoel had a cabin built for herself directly behind Sunset View.

She never married and was affectionately called "Auntie Til" by the townsfolk. She returned to Gold Hill every summer for the next twenty years.

Of the mountain town, one of the Chicago visitors repeated a quote from naturalist John Muir: "The winds will blow their own freshness into you and the storms their energy, while cares will drop off like autumn leaves."

Vanderpoel died in Chicago in 1950 at the age of eighty-nine. Her sister-in-law, Marie, known as "Grandma Van," stayed in Gold Hill for many more summers, and the home and cabin have remained in the family.

According to Vanderpoel's obituary, "she spent happy days painting" in her Gold Hill home. The early Chautauquans also acknowledged her expertise and stated in one of their bulletins that she had "attained an enviable reputation in her chosen field."

GEORGIA SNOW WORKED BEHIND THE SCENES AT PHOTO STUDIO

In 1903, shortly after Georgia McNaught graduated from high school, she was hired by Charles Gosha as an assistant in his photography studio. Six years later, Charles Snow, who had recently moved to Boulder from

Georgia Snow posed with her husband Charles and worked behind the scenes in the Snows' photography studio. *Courtesy of the author.*

Wisconsin, knocked on the door and was given the job (as described by the *Boulder Daily Camera*) of "a full-fledged photographer."

Little did Georgia know that she was about to embark on a forty-year partnership that would mix matrimony with a lifelong career.

She and Charles were engaged within a few months. Their wedding announcement identified Georgia as "a business woman of Boulder, having bought the photograph studio of C.E. Gosha some months ago." On the last day of business before the couple went to Denver for their wedding, Georgia put a sign on the door that stated that Charles Snow would be a partner in the studio upon their return.

The family business continued to grow when the newlyweds hired Charles's brother, Myron Snow. Shortly afterward, Myron married Georgia's sister, Fannie McNaught.

At the studio—first on Fourteenth Street and then on Broadway—Georgia worked quietly at Charles's side. He became internationally known for catching his subjects off-guard in order to capture their natural expressions in portraiture. Meanwhile, she did the developing in the darkroom and hand-tinted and retouched many of the photographs. She also managed the studio's business affairs.

Charles received more than six hundred awards from professional societies in twelve foreign countries. The *Daily Camera* acknowledged his prestigious career, but it also recognized Georgia's contribution and called her "an artist of note." An "S" in the lower-right corner of each photograph identifies their joint accomplishments.

With the assistance of Boulder architect Glen H. Huntington, Charles and Georgia built what a reporter called their "dream house." It's located on a knoll at the base of Flagstaff Mountain in today's Geneva Park neighborhood but is technically outside the city limits of Boulder. The still standing stone residence was designed in the shape of a cross to allow sunlight in winter but to keep out the hot summer sun.

Myron Snow's home was located next door. When Gordon Snow, one of Charles and Georgia's two sons, built his home two decades later, he chose a lot just uphill from his parents. At the time, there were no other houses in the immediate area, and the Snow homes collectively were called Snowhaven.

During this time, Charles and Georgia had hired another assistant named Edith Pendleton. Years later, when Charles was elected into the Royal

Photographic Society of Great Britain, the *Daily Camera* reported, "Mr. Snow attributes a great share of the success he has achieved to his wife, Mrs. Georgia Snow, and to Miss Edith Pendleton. The three have worked hard to constantly improve, and Boulder friends rejoice in their success."

Gordon Snow joined the family business in 1946, three years before his mother, Georgia, died at the age of sixty-four in 1949. The following year, Charles married his assistant, Edith Pendleton.

With Edith and Gordon, Charles continued to work in the Snow photography studio, but not before he scattered Georgia's ashes around her beloved home.

Muriel Sibell Wolle Remembered as Her Namesake Is Demolished

Muriel Sibell Wolle once stated that she was "not a historian nor a writer, but an artist gone slightly berserk." Long before most people thought about historic preservation, she sketched Colorado mining towns to create a pictorial record of their often decaying buildings before many of them disappeared.

If the former artist and University of Colorado fine arts professor were alive today, she probably would have sketched her namesake: the Sibell Wolle Fine Arts Building, until recently a part of the CU campus. The aging structure was used for many years by the fine arts department until its demolition, in 2008, to make way for the new Visual Arts Complex.

The red brick building originally comprised the "shops" for engineering students, who contributed to its design. Light filtered through a modified saw-tooth roof considered state-of-the-art at the time.

Muriel arrived in Boulder by train in 1926, when the building was only eight years old. The West was new to the petite and energetic New York native. Single and twenty-eight years old, she had studied advertising and costume design and then came to Boulder to teach art at CU.

After a visit to Central City, she stated that she felt challenged and stirred by the echoes, memories and history of the nearly deserted gold mining town.

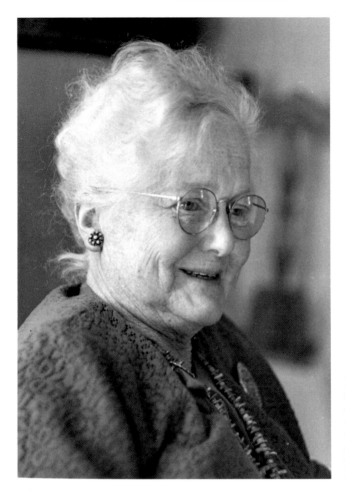

Muriel Sibell Wolle taught fine arts at the University of Colorado and was known for her sketches of mining towns. *Courtesy of the Daily Camera.*

During the school year, Muriel taught in the classroom. She never learned to drive, but every summer eager students chauffeured her around the mountains, where she made rough pencil sketches. She drew quickly, on the scene, and then took her sketches home, where she completed them with black crayon and occasionally watercolors.

Her finished drawings were representative rather than detailed. Her intent, she wrote, was to "catch the mood and quality of the town…with a sympathetic and dramatic interpretation."

Although Muriel's first objective was to get the deteriorating buildings down on paper, she realized that she needed to record the towns' histories as well. Her first book, titled *Ghost Cities of Colorado*, depicted the towns of

Central City, Black Hawk and Nevadaville. The next year, she published *Cloud Cities of Colorado*, primarily on Leadville.

Muriel married Francis Wolle (a CU English professor) and then wrote, under the name of Wolle, her most popular book, *Stampede to Timberline*. It was first published in 1949 and has become the "Bible" of Colorado ghost town books. It's still in print today and covers much on Boulder County.

By the time of the book's release, Muriel was the head of the fine arts department, a position she held until her retirement in 1966. Within a year of her death in 1977, she was honored by the university as one of three "alumni of the century."

Muriel Sibell Wolle is not likely to be forgotten. The bulk of her collection of drawings is located in the Denver Public Library. Also, some of the materials in the Sibell Wolle Fine Arts Building have been recycled in the building that replaced it. But those who want to remember the building as it was—if they didn't sketch it themselves—will have to settle for old photographs.

PART V
Musicians and Entertainers

TIGHTROPE WALKER IVY BALDWIN WAS AT HOME IN THE AIR

Ivy Baldwin loved being up in the air. The small, wiry stunt man performed in the United States and in Asia, but in Boulder County he made his home in the early twentieth-century resort town of Eldorado Springs, where he awed thousands of spectators for more than forty years with his high wire act over South Boulder Creek.

Baldwin was born in Houston, Texas, in 1866. At the age of thirteen, he watched a man walk on a tightrope and decided to try it himself. He crossed the San Antonio River on a wire and was immediately hired by a traveling circus as an aerialist.

In 1892, Baldwin took up hot air ballooning and thrilled crowds by jumping out with a parachute. He joined the circus and dived off a 150-foot tower in Japan. The emperor was so impressed that he presented Baldwin with a handmade silk kimono with a figure of his performance sewn into the garment.

During the Spanish-American War, Baldwin joined the aviation section of the Signal Corps. His hot air balloon was punctured by small arms fire during the Battle of Santiago, but he managed to land safely.

After the war, Baldwin moved to Eldorado Springs, south of Boulder. By 1905, tourists swam in what were advertised as "radium waters" and hiked

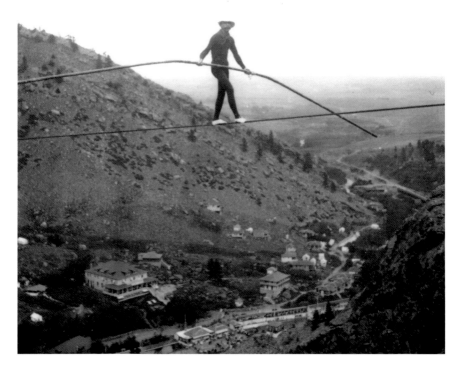

Without a net, Ivy Baldwin performed his high wire walk above the resort community of Eldorado Springs. *Courtesy of the Carnegie Branch Library for Local History, Boulder Historical Society Collection.*

in the rugged canyon. In the years to come, they arrived at the spa on the train and sipped lemonade on the porch of the New Eldorado Hotel. The crowds also provided a good audience for Baldwin.

From 1905 (when Baldwin was thirty-nine years old) to 1948, he walked a 635-foot tightrope 582 feet above South Boulder Creek. There was no net between his wire cable and the rocks and water below. He performed his act eighty-six times.

There were several occasions when the crowd feared that Baldwin might fall to his death. At least once he was temporarily blinded and had to be guided across by the voices of his assistants.

On another occasion, wind gusts of a quick-moving storm caught him in the center of his act, and he hung by his knees for half an hour until the storm subsided. Most crossings, however, took six and a half minutes.

He always wore cloth shoes with rosin soles and carried a twenty-six-foot balancing pole.

Baldwin walked the wire for the last time on his eighty-second birthday. Apparently, he had wanted to continue year after year, but members of his family "grounded" him instead.

At the age of eighty-seven, Baldwin was interviewed by the *Rocky Mountain News,* and he claimed that, given the opportunity, he could still walk the tightrope again. A month later, in October 1953, he died of a heart attack in his Eldorado Springs cabin.

Author Gene Fowler—whose father, Frank Fowler, owned the Eldorado Springs resort during its heyday—once stated that Baldwin was terrified below the ground. He said, "I recall once when he was tricked into going down into a mine, and he was scared out of his wits."

Fowler then added that, despite his subterranean fears, in the air Baldwin was the bravest man he ever saw.

Boulder-born O'Brien Starred in Theatre and Films

Eugene O'Brien, dapper and debonair star of Broadway theatre and silent films, was born and raised in Boulder. The *Boulder Daily Camera*'s editor stated that nothing pleased him more than the opportunity to chronicle the success of a native son. Boulder residents, including O'Brien's mother Kate (widow of police marshal John O'Brien), followed every achievement of the young actor's career.

In 1902, at the age of twenty-one, O'Brien (who had changed his name from Louis to Eugene) accepted a minor acting role in a stock company at Elitch Gardens in Denver. Before long, the handsome University of Colorado medical school dropout moved to New York City, where his rich baritone voice landed him the part of a Hungarian soldier in a vaudeville play.

"Less than three months ago, the name of Eugene O'Brien had about as much significance for Broadway theatregoers as that of the most obscure actor in some far-off rural community," noted the local newspaper when quoting a New York critic in 1909. "Yet, in one single night, [O'Brien] achieved a success, the glory of which must ring in his ears yet."

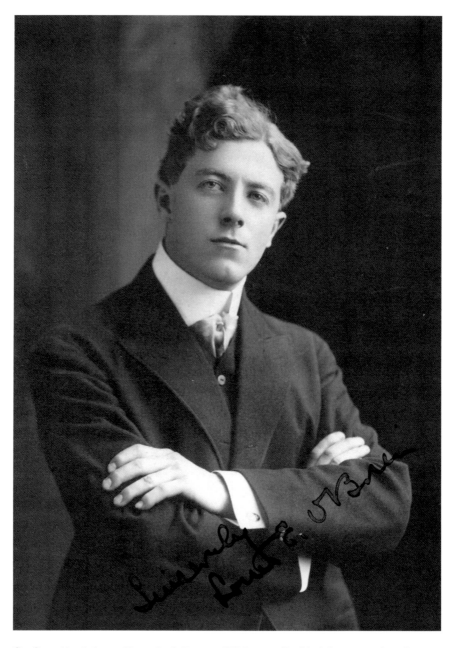

Confirmed bachelor and heartthrob Eugene O'Brien was Boulder's hometown hero in silent films and Broadway theatrical performances. *Courtesy of the Carnegie Branch Library for Local History, Boulder Historical Society Collection.*

Boulder family and friends finally got to see O'Brien perform when he appeared in his first silent film, *The Lieutenant Governor*. It was shown in February 1915 at the Curran Theatre, the site of the Boulder Theatre on Fourteenth Street. Before long, the young actor co-starred with early film favorites Mary Pickford, Norma Talmadge and Gloria Swanson.

O'Brien's fans soon learned that he was insured for $1 million, received "an almost unbelievable salary" and was appearing in moving pictures all over the world. A female reporter who interviewed him on the set of *The Perfect Lover* found him "only a bit better looking than I ever imagined any man could be."

A local reporter interviewed him on a visit to Boulder, en route from Hollywood to New York. O'Brien said that he had noticed many improvements in Boulder and that walking the streets made him feel like a boy again.

He also stated that he was anxious to return to the "legitimate stage" and preferred acting before an audience to being in films. By 1928, during the era when "talkies" made their debut, O'Brien left the movie industry for good.

In 1929, at the age of forty-eight, he moved into a Hollywood hacienda. A newspaper reporter noted that O'Brien was "untroubled by girls and reveling in athletics, gardening, and most of all in bachelorhood." O'Brien told the reporter that he would never marry because women were too possessive. He said he liked to do as he pleased at all hours and particularly enjoyed mornings alone.

The aging stage and silent film star made his final visit to Boulder in 1952 for the funeral of his brother, George. But Boulder stayed in the mind of the hometown hero.

O'Brien died in 1966 at the age of eighty-five. His funeral was in Hollywood, but his body was returned to Boulder and interred next to his parents and brothers in the O'Brien family plot at Green Mountain Cemetery.

Boulder's native son is now back home.

JAZZ MUSICIAN MORRISON GOT HIS START IN BOULDER COUNTY

George Morrison was only nine years old in 1900 when he moved to Boulder with his mother, brothers and sisters. Talent had come naturally to the youngest of fourteen in a Missouri-born musical family. Before long, George and his brothers formed the Morrison Brothers String Band. It got its start in the mining camps west of Boulder.

To earn money for guitar and violin lessons, Morrison worked in the kitchen of the Delta Tau Delta fraternity house and also took a job as a shoeshine boy in a Pearl Street barbershop. He later outshined his brothers and became a renowned jazz musician.

According to a newspaper interview from years ago, the naïve but eager country boys slid up and down the dangerous canyon roads in a horse and buggy, playing in any kind of building they could find. By 1914, the band was renamed the Morrison Orchestra, with local manager Lester Rinehart. Notices in the *Boulder Daily Camera* often announced, "Music by the Morrison Brothers of Boulder" or advertised "dances by Rinehart and his colored company."

On many occasions, these dances were held in the schoolhouses of Salina, Sunset, Gold Hill and Sugar Loaf. Popular tunes at the time were "Silver Threads Among the Gold" and "After the Ball." When the Morrison Brothers didn't have a formal engagement, they played for donations on Pearl Street, just as street musicians do today.

Morrison eventually played in jazz bands all over the country and in Europe, but he fiddled away the better part of his career in Denver. For several years, he directed an orchestra at Denver's Albany Hotel. In 1919, he and his band went to New York and made a series of recordings for Columbia Records.

In his later life, Morrison taught, composed and arranged music, and he especially enjoyed arranging popular tunes for a full orchestra. He was said to have played late into the night, and then he would get up early on Sunday mornings to sing in his church choir.

In 1970, George Morrison told a *Daily Camera* reporter that he had always wanted to be a concert violinist but that he was barred from a career in a symphony orchestra because he was black. One of the conductors of the

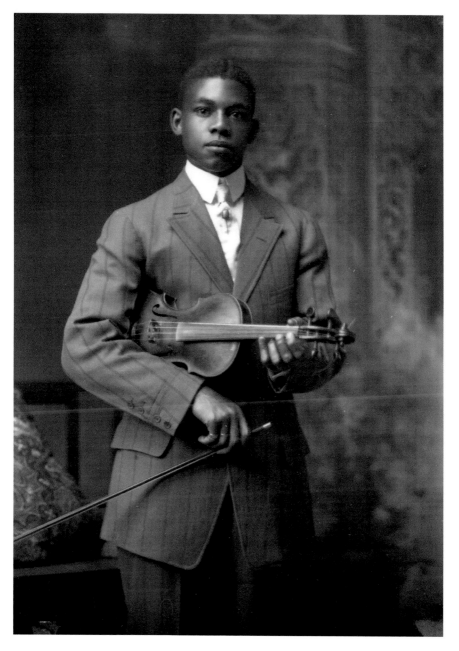

Jazz musician George Morrison got his start in Boulder County. *Courtesy of the Carnegie Branch Library for Local History, Boulder Historical Society Collection.*

Denver Symphony even told him, "I'd have you as my concert master if you were a white man."

One of Morrison's protégés was Paul Whiteman, a white musician who was dubbed the "King of Jazz." Ironically, Morrison was later called "the black Paul Whiteman." Morrison, who died of cancer in 1974 at the age of eighty-three, included Jelly Roll Morton, Scott Joplin and Duke Ellington among his friends.

To see one of the venues in which George Morrison and his brothers got their start, take Boulder Canyon to Four Mile Canyon and turn right on Gold Run Road until you reach the Salina Schoolhouse. The restored building dates from 1885 and looks the same as when the Morrison Brothers played there many years ago.

GLENN MILLER PLAYED AT DANCE HALLS IN THE ROARING TWENTIES

Dancing to live music has always been popular in the Boulder area, but its liveliest times date from the 1920s. That's when the Holly Moyer Orchestra played jazz in Boulder, with trombonist Glenn Miller as part of the group.

Miller, a University of Colorado student, joined Moyer's Orchestra in November 1922 during a performance in Citizens' Hall. The popular downtown venue was on the third floor of the Citizens' Bank Building, still standing on the Pearl Street Mall between Fourteenth and Fifteenth Streets.

College students walked down, and back, from CU and mingled with other young couples in town. A *Boulder Daily Camera* ad from the era called the dance hall "the logical place to strut your date" and promised "hot music, a cool hall, and a good time."

Admission ranged from $0.20 for ladies ($0.40 for men) during the week to $1.10 per couple on Friday evenings. The orchestra kept dancers moving with waltzes, the two-step, the fox trot and a Roaring Twenties fad called the "flea hop."

Moyer's Orchestra—including Miller—also played in at least two other local dance halls, Cañon Park Dance Pavilion at the mouth of Boulder Canyon and the dance hall in Eldorado Springs, south of Boulder. Cañon Park opened in the spring of 1923 and catered to both high school and college students.

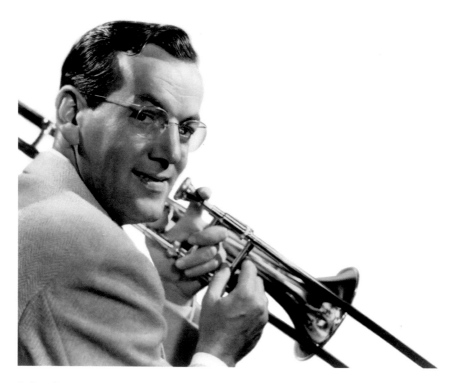

Before Glenn Miller became famous, the trombone player and University of Colorado student played at several Boulder County dance halls. *Courtesy of the Glenn Miller Archives, University of Colorado.*

Liquor was illegal in Boulder at the time, but after national prohibition was lifted in 1933, Cañon Park (outside the city limits) served 3.2 percent beer. Whiskey was also sipped indiscreetly in the parking lot. The hall burned down in September 1942, and a proposal to rebuild it in 1948 was met with angry letters from neighbors with concerns about "drunks."

Moyer's Orchestra played in Eldorado Springs before its dance hall burned down in 1929. It was quickly rebuilt and then was washed out in the flood of 1938 and rebuilt again. By that time, Glenn Miller had become a big-band leader with his own Glenn Miller Band and was long gone from the Boulder dance scene.

Except for Miller and alto saxophonist Jack Bunch, who moved to California and sold real estate, the remaining members of Moyer's six-man orchestra stayed in the Boulder-Denver area. Drummer J.H. Kingdom worked his way

up the corporate ladder in Boulder's First National Bank. Banjo player Emil Christensen joined a Denver brokerage firm. Bill Fairchild, who played the tenor saxophone, opened Fairchild's Distinctive Furniture Store in Boulder. And Moyer, the leader and pianist, became a piano and organ salesman for Knight-Campbell Music Company.

Although the Boulder-area dance halls continued to draw dancers in the 1930s and 1940s, the Depression cut into most everyone's pockets, and World War II diverted nearly everyone's thoughts.

Prior to 1950, Citizens' Hall was still in occasional use for dances. Then it was mostly vacant until 1973, when the Good Earth nightclub briefly offered dining and entertainment. But the dance hall days of Cañon Park and Eldorado Springs were over. Even in Citizens' Hall, the atmosphere of the Roaring Twenties was never revived.

JOSEPHINE ANTOINE'S FOLLOWERS HUNG ON EVERY NOTE

In 1928, when twenty-year-old singer Josephine Antoine performed a solo concert in the University of Colorado's Macky Auditorium, a seasoned music critic wrote, "It did not seem possible that it could be a Boulder girl standing there." The local residents hung on her every note, and then they followed her career as the blonde, blue-eyed coloratura (a soprano who specialized in trills and runs) rose to become a national star.

As a child, Antoine claimed that all she ever wanted to do was to sing and play the piano. She had moved with her parents to Boulder in 1913 when she was five years old. After University Hill Elementary School, she went to State Preparatory School, where she was president of the Glee Club. At CU, she took voice lessons and earned her tuition by teaching piano.

Antoine graduated from CU in 1929 and then traveled to New York and won a scholarship in a national singing competition. Her parents and a dedicated group of Boulder friends were in the audience. A couple of years later, she returned to Boulder and gave another concert in Macky Auditorium, where she told reporters that she was thrilled to be singing to the people of Boulder, her first friends.

Boulder's Josephine Antoine rose to fame as a Metropolitan opera star. *Courtesy of the Carnegie Branch Library for Local History, Boulder Historical Society Collection.*

In 1936, before her first performance in the Metropolitan Opera in New York, she received a telegram from Boulder mayor Howard Heuston that read, "Every citizen sends you love and good wishes for your performance tomorrow."

Antoine was honored in a meeting with President and Mrs. Herbert Hoover, and then she returned to Boulder, where she was given an enthusiastic reception. A *Boulder Daily Camera* reporter wrote that the news of her arrival "electrified Boulder."

Heuston headed the welcoming committee. When Antoine was spotted being driven into town, chimes rang in St. John's Episcopal Church, signaling the citizens' and children's choirs to begin their concert on the courthouse lawn.

Although she never forgot her loyal fans, Antoine spent more time away from Boulder than in her hometown. She soon began a master's degree program at the Juilliard School of Music in New York, was a soloist in a performance of Handel's *Messiah* in Carnegie Hall and sang in several Mozart operas including *The Secret Marriage* at the Library of Congress in Washington, D.C.

In addition to singing the lead in fourteen productions with the Metropolitan Opera, Antoine traveled all over the country. In Colorado, she performed in the *Bartered Bride* with the Central City Opera and also sang on many national radio programs including *The Ford Hour*, *The Palmolive Hour* and *The Packard Hour*.

Antoine married in 1947 and then raised a daughter and taught music. She gave one last Boulder concert in 1955. She was a professor of voice at the University of Rochester's Eastman School of Music when she died in 1971 at the age of sixty-four.

Everyone was impressed with the hometown girl who found national fame. One concertgoer, in 1930, scribbled on the back of a concert program, "Little Miss Antoine, of Boulder, stopped the show. Even the drunks listened to her. What a voice that youngster has."

CHAUTAUQUA ENTERTAINER MIMICKED BIRD SOUNDS

Boulder children of the 1920s and 1930s loved to see Chautauqua entertainer Charles Bowman Hutchins, better known as the "Birdman." The naturalist captivated children by making colored crayon drawings while whistling various bird songs to the accompaniment of his wife on the harp.

"The way the 'Birdman' can hold the attention of great crowds of children is remarkable," reported a *Boulder Daily Camera* writer at the time. "Coming onto the stage with a boyish grin on his face, he may proceed at once to catch a small imaginary chicken which is running about peeping wildly for its mother."

Hutchins would dash after his quarry while his youthful audience, scarcely breathing, watched his every move. Then he would swoop down, cover the "chick" with his handkerchief, snuggle it up while it "peeped" and then—without a moment's pause—address the audience while he shook out his handkerchief and returned it to his pocket.

Charles Bowman Hutchins, better known as the "Birdman," posed in the mid-1920s with a live bird. *Courtesy of the Carnegie Branch Library for Local History, Boulder Historical Society Collection.*

The Birdman's interest in birds began when he was a young child growing up in the state of Washington. He had loved the solitude of the woods and spent his time building birdhouses. Other children called him "the Bird Nut" until he found a teacher who encouraged him to learn all he could about birds and make them his life's work. Promotional literature called him an "interpreter" of the forests in the same class as Thoreau, Audubon and Muir.

From 1927 to 1937, Hutchins and his wife, Helen, spent their summers as ranger naturalists, lecturing to tourists in Rocky Mountain and Yellowstone National Parks, where they painted birds in their natural habitat. Back at Chautauqua, the Hutchinses led bird-watching hikes to the amphitheatre on Flagstaff Mountain.

In the auditorium, Hutchins's act was said to make "birds and forests quickly appear before your eyes." A newspaper reporter continued to describe the entertainer's performances: "He speaks earnestly for a few moments, and then just as a small boy shows the slightest sign that he is about to get restless, suddenly there comes from the throat of the speaker

the call of a bob white, or the song of the whippoorwill, or the clear, limpid notes of the thrush."

Next, Hutchins would step up to his easel and, with colored crayon, sketch a picture of a bird on the branch of a tree. His strokes were so rapid that his young listeners watched him as they would a magician. Hutchins then told a running story of the bird and its habits, while making the sketch. When a pianist (usually his wife) played "My Old Kentucky Home" or "Home Sweet Home," Hutchins would accompany the music with bird songs or calls.

Longtime Chautauqua resident Mary Bradford Rovetta, who was a child at the time, said that all the children wanted to sit in the front row because the Birdman would hand out drawings each time he made a new one.

The children also learned a lesson that ran all through the performance: "Know the birds, love the birds, do not kill the birds."

REVEILLE WITH BEVERLY CHEERED TROOPS IN THE 1940S

When the World War II Memorial was being unveiled in Washington, D.C., in 2004, a former Boulder girl was in attendance. Beginning in 1941, Jean Ruth Hay (then Jean Ruth) was the "girl next door" who cheered the troops with her early morning radio show *Reveille with Beverly*.

Hay's program was an immediate hit, launching the young woman—known on the radio as "Beverly"—into the role of the world's first female disc jockey. She had no script, but she read highlights of letters from her listeners and played the 1940s swing music that they loved and requested.

"I was not just the entertainer for the troops out there," she stated in an interview. "We were in this together. There was an intimacy before dawn as the microphone took my voice directly into their barracks."

The State Preparatory School and University of Colorado alum got her start in radio on Denver station KFEL. Six days a week, Hay arrived at the studio in time to prepare for her hour-long show that started at 5:30am. Her soft, warm voice, interspersed with the strains of Glenn Miller, Duke Ellington and Tommy Dorsey, boosted morale and eased the early morning hours for soldiers from Denver to Cheyenne.

Jean Ruth (Hay) was living in Boulder in 1941 when she launched her radio show *Reveille with Beverly*. *Courtesy of the* Daily Camera.

Within a few months, Hay became nationally known. In January 1942, *Time* magazine called her "dawn's early lightener" and reported that she was directly responsible for waking up twenty-eight thousand servicemen at three army posts, including Fort Logan in Denver.

In the summer of 1942, the energetic young woman traveled to Hollywood to meet with producers of a movie version of *Reveille with Beverly*. Although Hay did not appear in the star-studded musical, she stayed on as technical director, urging that musical selections be played in their entirety. The film was released in 1943 with Ann Miller as the star, and it featured bands and vocalists that included Bob Crosby, Duke Ellington and Frank Sinatra, as well as band leader Freddie Slack, who became Hay's first husband.

Throughout the remainder of World War II, Hay continued her *Reveille with Beverly* radio show in Hollywood. The newly formed Armed Forces Radio Service broadcasted the show to eleven million servicemen in fifty-four countries. At the end of the war, when Hay's husband went on a band tour, she lived with her mother in Boulder and hosted a radio program on the Boulder radio station KBOL.

By 1953, Hay had married second husband John Hay and returned to Hollywood, where she switched from radio to a long and illustrious television career. She continued to live in California but returned to Boulder for occasional high school reunions.

Hay died in September 2004 at the age of eighty-seven, but she always had a special fondness for the soldiers. "They came from all across America—the cities, the slums, the farms and little towns," she once said. "I was their age—just learning my craft as they were learning theirs. My music smoothed the way, softened the fears and developed camaraderie among young men, some of whom were listening to radio for the very first time."

Stripper Tempest Storm Visited CU Campus in 1955

When Tempest Storm visited the University of Colorado campus in January 1955, all she took off was her mink coat, but that was enough to start a near riot. It culminated in a broken door casing on the new student union building—the University Memorial Center—followed by a dramatic getaway in order to protect her well-insured body.

The then twenty-seven-year-old burlesque queen was born in Eastman, Georgia, as Annie Banks. In the late 1940s, she moved to Los Angeles, where she started a career as a chorus line dancer. With an extremely well-endowed

Stripper Tempest Storm only took off her mink coat, but she caused a near riot when she visited the University of Colorado campus in 1955. *Courtesy of the* Daily Camera.

figure and flaming red hair, she quickly advanced to shedding her clothes on stage and legally changed her name to Tempest Storm.

At the time, CU had a humor magazine called *Flatiron*. A month before Storm's visit, administrators had temporarily suspended the magazine's publication for what one university official termed "too much sex and emphasis on alcohol."

Even so, *Flatiron* photo editor Bob Latham invited Storm to the campus to pose for some "cheesecake" shots. As soon as the stripper's visit was announced, CU president Dr. Ward Darley made it clear that she was not welcome. "This proposal to use University facilities for publicizing a night club entertainer is inconsistent with the dignity and purpose of a state university," he stated. Adding to Darley's worries was his concern that the timing of Storm's arrival would coincide with a scheduled visit of fifty state legislators.

Although Latham claimed to have withdrawn his invitation, the publicity-seeker drove her own red Cadillac convertible from the Tropics Nightclub in Denver, where she was currently performing. Of President Darley, Storm told a reporter, "I don't understand his attitude. My profession is not undignified. It's art."

Latham escorted her from her car. In a later telephone interview, he said, "The men came out like ants. It was like being in a river."

When Latham and Storm entered the cafeteria of the student union building, they were crushed by another mob of whistling, yelling and shouting male students. The *Boulder Daily Camera* reported that the men damaged tables and chairs and broke glasses and dishes while clamoring for a better view. Interviewers were more interested in Storm's bust measurement than in her safety.

After a half hour, Storm asked to leave, so some of the students hoisted her onto their shoulders. They broke into a run, one student stumbled and Storm was thrown to the sidewalk. On the verge of tears, she was carried to her car. She sped away, just fifteen minutes before the legislators arrived for their official campus inspection.

Of Storm's CU visit, the *Daily Camera* concluded, "Both are the worse for the wear."

In subsequent years, Storm moved from live burlesque shows to movies, which included titles such as *Strip, Strip Hooray*. Her most recent film was *Hollywood and the Strippers*, released in 1994. Latham, now retired and living in Florida, dropped out of CU to become a newspaper photographer.

After a few months of suspension, the *Flatiron* magazine was reinstated. If Latham managed to take any photos of Storm, they were not printed in any university-sanctioned publication.

PART VI

Entrepreneurs

ANDREW J. MACKY WAS A SELF-MADE MAN

Members of the University of Colorado Board of Regents recently resurrected a resolution passed more than a century ago to place a wreath every year on the grave of Andrew J. Macky at Columbia Cemetery. Before the Boulder benefactor died in June 1907, he had willed his considerable estate to CU for the construction of Macky Auditorium.

According to the 1908 regents' minutes, the wreath was meant as a gesture of appreciation for Macky's generosity. But the Boulder pioneer left more to Boulder than his money and his name. He was a self-made man who worked hard to achieve the wealth that he ultimately gave away.

Macky had arrived in Colorado Territory in 1859 as one of a Wisconsin party of young men, all eager to strike it rich in Colorado's gold rush. They searched for gold but got discouraged and decided to find other ways to make their livings.

Some of the men, including Macky, ended up in Boulder. When Macky arrived, the town was merely a cluster of log cabins. As a skilled carpenter, he built and lived in Boulder's first frame house, then located on the northeast corner of Pearl and Fourteenth Streets.

At the time, Macky's house was the largest and nicest building in Boulder, so he made it available for court sessions, public meetings and dances. For eight years, he ran the post office out of his home and served as postmaster.

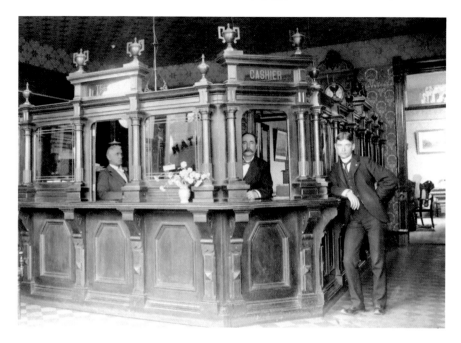

Andrew J. Macky sat in the teller window on the left when this 1898 photo was taken of the interior of First National Bank. *Courtesy of the Carnegie Branch Library for Local History, Boulder Historical Society Collection.*

In 1866, he built Boulder's first commercial brick building. Neither of these buildings are still standing today.

Before long, Macky emerged as a community leader and served on the school board. He also became town clerk and treasurer, justice of the peace and clerk of the district court. He found time to marry and adopt a daughter, and he became active in several fraternal organizations, as well as the Boulder County Pioneers and the Association of Colorado Pioneers.

By the 1870s, Boulder County's gold and silver discoveries began to pour money into the local economy. Macky helped to organize the First National Bank of Boulder in 1877. Eight years later, he became its president.

Macky, also on his own, provided investors with high-interest short-term loans. He was part owner of the Boulder Milling and Elevator Company and was secretary and treasurer of the company that platted and sold real estate on Mapleton Hill.

At the age of sixty-eight, Boulder's then richest resident parted with some of his accumulated wealth when he paid the then exorbitant price of $1,345 for one of Boulder's first automobiles, a 1902 Mobile Steamer.

Two years after Macky's death, the university broke ground for the auditorium that would bear his name. The cornerstone was laid a year later, but his adopted daughter contested the will and delayed construction. The building was in use in 1912, but the offices and the 2,600-seat auditorium were not completely finished until 1922.

Macky did well in his life, but he had never had a university education. At the time of the auditorium's completion, a reporter for a CU publication wrote that Macky "was among those rare persons who are willing to give their all that others might enjoy privileges that they had been denied."

HENRY DRUMM MADE MAPMAKING HIS FINAL CAREER

Most people who have referenced the historic Boulder-area maps compiled and drawn by Henry Drumm have marveled at the author's skill. But few admirers are aware that Drumm was in the University of Colorado's first graduating class and had a long and distinguished career in law and in the legislature in addition to his profession as a master mapmaker.

Drumm arrived in Boulder County as a boy to join his father, who had settled in Valmont, east of Boulder. In 1871, with his mother and siblings, Drumm traveled by train from Iowa to Denver, where his father met the family in a lumber wagon and drove them to their new home.

To earn money for his education, Drumm worked as a barber—even after he entered CU, where he was one of six students in the class of 1882. Because diplomas were handed out in alphabetical order, Drumm officially became the university's very first graduate.

He then took on the jobs of a newspaper reporter and a schoolteacher. He also was a police magistrate and assisted in the survey of the narrow-gauge railroad that ran into the mountains west of Boulder. Beginning in 1883, Drumm attended law school at Columbia University in New York and then returned to Colorado, where he was admitted to the bar.

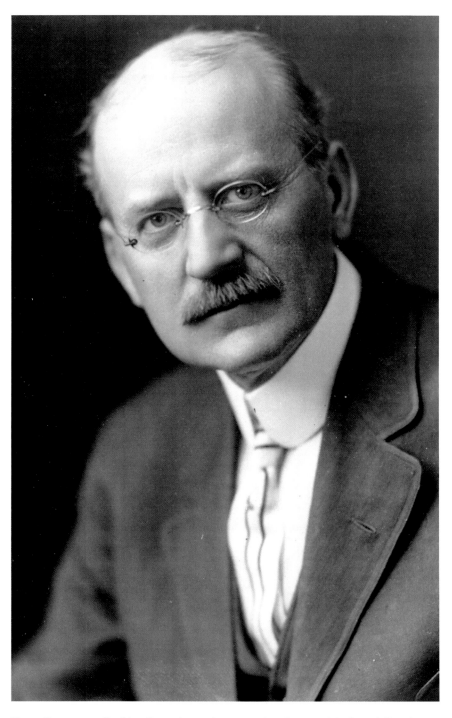

Henry Drumm was Boulder County's premier mapmaker. *Courtesy of the Carnegie Branch Library for Local History, Boulder Historical Society Collection.*

After a few years in Boulder, Drumm continued his law practice in Omaha, Nebraska, where he was also a clerk of the probate court and then a draftsman for the Union Pacific Railroad.

In 1896, with his first wife, Estella (daughter of Boulder pioneer Marinus Smith), Drumm returned to Boulder and resumed his law practice. Two years later, he was elected to the Colorado House of Representatives. In 1900, at the Democratic National Convention, he seconded William Jennings Bryan's nomination for U.S. president.

Finally, from the early 1900s through the 1930s, Drumm drew on his draftsman's skills and turned to mapmaking as his final career. He compiled, drew and published maps for municipalities, businesses and oil and mining companies. According to his obituary writer, the maps were "models of accuracy and neatness."

After Estella's death and five years on his own, Drumm married Laura Bruckner. Their children remembered Drumm as a perfectionist who often stayed late at his office and then expected his wife and children to stay up and have dinner with him when he got home.

Originals and copies of Drumm's maps are available to researchers at the Carnegie Branch Library for Local History, at 1125 Pine Street in Boulder. An original 1914 *Drumm's Wall Map of Boulder County, Colorado* is prominently displayed in the Boulder County Clerk and Recorder's Office at 1750 Thirty-third Street.

In addition to cities and towns, the county map includes roads, railroads and mining claims and is in demand by property owners—and their attorneys—to settle property and road disputes. Drumm's detailed and artistic road survey maps can also be viewed at the county Transportation Department and at the office of the Boulder County Commissioners.

Drumm died in 1937. Of his mapmaking abilities, a newspaper writer extolled his talents and duly stated, "[He] had no peer in that line of work."

BOULDER'S FIRST FEMALE TAXI DRIVERS WERE A HIT

When the flu epidemic hit Boulder in 1918, an undertaker was unable to get over a rough dirt road to pick up the body of a young woman and take her to

Mabel MacLeay, *left*, and Florence Molloy posed with their taxis and an unnamed dog on Spruce Street in 1922. *Courtesy of the Carnegie Branch Library for Local History, Boulder Historical Society Collection.*

the morgue. Florence Molloy, a thirty-eight-year-old widow, stepped in and managed to reach the woman's isolated cabin. Afterward, Molloy said that no job was too difficult to handle.

Molloy and another widow, Mabel MacLeay, then started a taxi service, the first in Boulder to be run by women. They lived in the historic stone Squires-Tourtellot House at 1019 Spruce Street. Old-timers remember the women as opposites. MacLeay was ladylike and petite, while Molloy was a stalwart six-footer. Both women had come to Boulder from Syracuse, New York.

Beginning in 1922, Molloy and MacLeay ran their business from an office in the Hotel Boulderado. During the winters, they took riders all over Boulder for a quarter. They refused to pick up drunks or transport liquor. Their ads stated, "We use the Cadillac 8. Careful drivers."

In a newspaper interview at the time, the women told a reporter that "taxi driving is a safe and sane occupation for any woman who has coolness, courage, and a thorough knowledge of how to operate a car."

Every summer, the two women took college students for scenic drives in the mountains. Molloy had two daughters, and MacLeay had a son, all students at the University of Colorado, so the women were often involved in student activities.

Helen Carpenter was a CU student in the early 1920s. In a taped interview in 1986, she praised Molloy and stated, "My gang of girls went everywhere with Mrs. Molloy. She took us to football games and to Estes Park for dinner."

Tourists also booked Molloy and MacLeay for mountain trips. The women added a Pierce Arrow and a Packard to their fleet of luxury touring cars. The roundtrip charge to Estes Park was seven dollars, but it was usually split by seven or eight passengers. Among the women's distinguished passengers were attorney Clarence Darrow—visiting his friend Jean Sherwood in Gold Hill—and opera singer Madame Schumann-Heink.

When not off in the mountains, Molloy and MacLeay were on hand at Boulder's Union Pacific Depot to meet the daily Colorado & Southern passenger trains. The women competed against five or six other companies, including Cliff's Taxi Service, Harry's Taxi and Hall's Taxi. But ask those who were in Boulder in the 1920s, and Molloy and MacLeay were the only drivers they remember.

In 1927, the two women opened a dude ranch in Gold Hill. They named it the Double M, for their initials, and offered mountain vacations along with their scenic tours. The property later became the Trojan Ranch and is now Colorado Mountain Ranch.

MacLeay died in 1950 and Molloy in 1951. Molloy, especially, made a big impression on her riders. In Carpenter's interview, she said, "Mrs. Molloy was a marvelous driver—a great big masculine woman. She could have picked up an automobile. I would have driven anywhere in the world with her."

MINERS DOPP AND WALKER COMPETED
IN ROCK-DRILLING

In May 1937, while the Great Depression kept most of Boulder County's residents close to home, Fred Dopp and Archie Walker—part of a small group of local miners skilled in hand-drilling—traveled to San Francisco, California, to compete in the national hard rock mining competition.

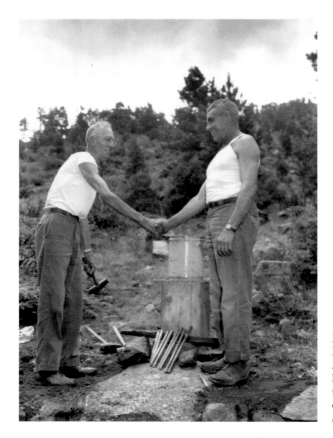

Longtime drilling rivals Fred Dopp, *left*, and Archie Walker shook hands after one of their hard rock drilling competitions. *Courtesy of the* Daily Camera.

According to the *Boulder Daily Camera*, the Boulder men "made a clean sweep."

Even today, the mining process consists of drilling eight to twelve holes into a "working face," packing the holes with explosives and then blasting the rock in order to remove gold-bearing vein material. Long ago, pneumatic drills—run on compressed air—rendered hand-drilling obsolete, but as early as 1870, mining contests kept alive the skills of the frontier miner.

At first, these contests were held between employees of individual mines and then between the best drillers of rival mining camps. Eventually, counties picked their champions, who competed each year in a state competition. There were two types of hand-drilling: single-jacking, in which a man worked alone; or double-jacking, in which two men worked as a team.

The contests in California in 1937 were part of a weeklong celebration at the opening of the Golden Gate Bridge. Boulder County sent only its best miners. Jamestown resident Dopp, at the age of fifty-three, retained his

national single-jacking championship by drilling a twenty-one-inch hole into a four-ton block of granite in fifteen minutes.

With hundreds of onlookers cheering him on, Dopp held the chisel-like drill steel with his left hand, while, with his right, he was said to have delivered seventy to eighty blows per minute with a four-pound hammer. As he pounded the steel into the rock, he continuously turned it and, at intervals, replaced the steels with those of increasingly longer length.

E.A. Saunders, a member of the Boulder Fire Department, and his partner Archie Walker of Jamestown, set a new national record in the double-jacking championship with a drill hole of thirty-three and one-eighth inches. In this two-man contest, one man would turn and replace the drill steels while the other wielded a heavy sledgehammer. The men alternated places without missing a beat.

When Dopp, Saunders and Walker competed in the national mining contests in California, Dopp had been undefeated for thirty years. A few months after the Boulder County men came home, the three men entered another contest in Central City.

For the first time, Dopp was defeated, and the loss was to Walker. Years later, Dopp told a reporter, "Arch and I went back that same night, and I beat him, just to prove I could."

Boulder has only a few reminders of its mining heritage, but in 1959, Dopp presided over the unveiling of a block of granite still located near the Grant Street entrance to Chautauqua Park.

The rock, complete with drill holes, has a bronze plaque that reads:

> *In honor of all the hard rock miners who contributed so much to the development of this area and in recognition of the mining industry, this monument was erected by the Boulder Chamber of Commerce in Boulder's centennial year 1959.*

Johnson's Popcorn Wagon Was a Downtown Boulder Institution

In 1935, when vendor Chester Johnson was interviewed by the *Boulder Daily Camera*, he had manned his popcorn wagon on Thirteenth Street,

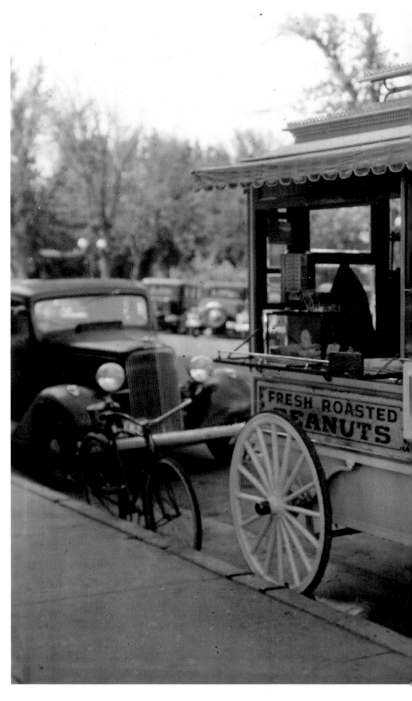

For forty years, Chester Johnson operated this popcorn wagon on the northwest corner of Pearl and Thirteenth Streets. *Courtesy of the Carnegie Branch Library for Local History, Boulder Historical Society Collection.*

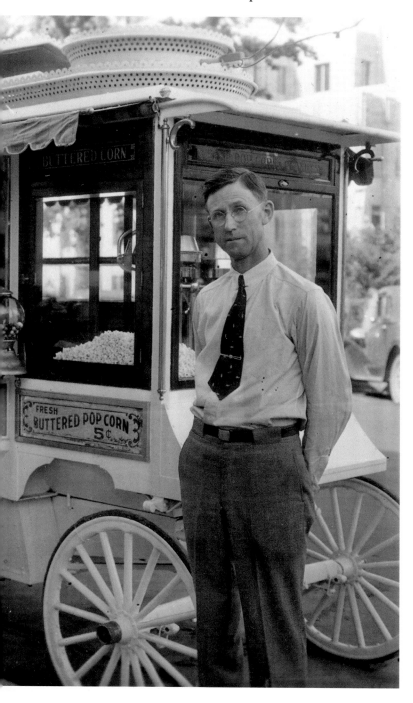

near its intersection with Pearl Street, for two decades. He would remain for two more.

Although the cart was designed to be pulled by a horse, it never left the street corner next to the Boulder National Bank, now the Boulder Café. For forty years, Johnson's popcorn wagon was one of downtown Boulder's best-loved institutions.

Beginning in 1916, Johnson had worked as a motorman on a Boulder streetcar and occasionally helped his father run the popcorn wagon. A few years later, the elder Johnson got a position as a Boulder police officer, and Chester Johnson took on most of the vending job himself.

Every day, Johnson rode his bicycle from his home on Pine Street. If he got downtown early, which he often did, he played cards with his friends in the old Elks Lodge, now the Courthouse Annex on the southwest corner of Spruce and Thirteenth Streets.

Except for a one-week vacation every September, Johnson manned his wagon from 2:30 p.m. to 10:30 p.m. throughout the week and until 11:00 p.m. on Saturdays. On holidays and special occasions, he was open in the mornings, as well. He always had a book with him to fill his time on slow days.

At one side of the wagon was a small low-pressure boiler heated with white gas. The boiler fueled a steam engine that stirred the corn in a kettle-type popper in which butter and salt were mixed with the popcorn and actually cooked into the kernels. Johnson advertised that he only used corn from Boulder County.

Steam power also turned a peanut roaster. During the winter, Johnson directed the steam into a floor vent to keep the wagon heated. "This engine has never failed me," he stated in an interview at the time. "There's nothing old-fashioned about the usefulness of steam."

Peanut and popcorn customers often stood at Johnson's wagon for ten or fifteen minutes at a time, just watching the steam engine run. Johnson also sold gum and candy

After World War II, Boulder grew and changed, but Johnson and his popcorn wagon remained the same. At the time, historian Forest Crossen described the wagon as "quaint" and "lost in the shuffle of time." Its bright-red steel body held window sashes of birch that were decorated with white trim and fancy gingerbread. Gilt scrollwork ornamented the

window glass. Underneath the wagon, rubber tires were mounted on wheels with high spokes.

In 1956, illness forced Johnson to retire. That same year, Cañon City resident Don Tyner purchased the popcorn wagon and moved it to his Park View Motel.

The original 1910 wagon, from Cretors & Company in Chicago, was called "the improved special, model D." It had cost $1,400 new, equivalent to $27,000 (based on the consumer price index) in today's currency. Its selling price in 1956 was not recorded.

Boulder residents were sorry to see Johnson and his popcorn wagon go. Chester Johnson, the "popcorn man," died in 1961 at the age of seventy-nine.

Newlyweds Received Hotel Boulderado as Wedding Gift

Rosemary "Winnie" Hutson, a young beauty queen, got more than a husband when she married William "Bill" Hutson Jr. His father bought them the Hotel Boulderado and gave it to them as a wedding present.

The couple married in January 1939. Winnie had won the title of "Miss Kansas." Then she became a close runner-up in the "Miss America" contest in Atlantic City, New Jersey.

Bill had attended Cornell University Hotel School and came from a well-respected hotel-owning family. His father owned and operated a series of hotels in Kansas and Missouri. When William Hutson Sr. bought the Boulderado, he turned the management over to the newlyweds. Winnie turned down an offer to act in Hollywood to help her husband run the hotel.

The Great Depression had brought an end to the hotel's former glory, but the Hutsons had to wait until after World War II to modernize and remodel. They converted the coal furnace to natural gas and replaced original gaslight and electric light fixtures with new electric lights. Two- and three-room apartments were created out of several smaller rooms. Fluorescent lights illuminated the lobby, and an imposing neon sign glowed from the roof.

The old formal dining room had been closed during the war years, and rats ran freely around the kitchen. Staff members baited them with meat

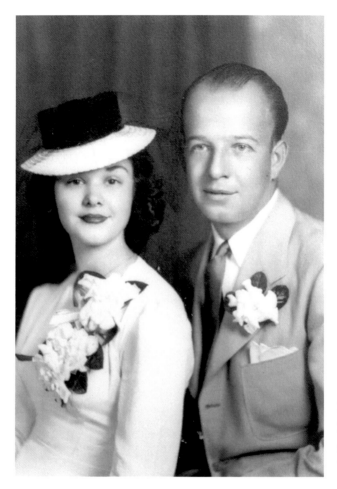

In 1940, Winnie and Bill Hutson received the Hotel Boulderado from Bill's father as a wedding present. *Courtesy of the author.*

over barrels of water. But the public only saw the new U-shaped lunch counter and soda fountain–style booths, which gave the Boulderado Coffee Shop a more casual look.

Within a few years, longtime employee Ralph Hume took over the hotel's management, while Winnie and Bill managed the restaurant. In the 1950s, they served choice prime rib of beef au jus, with potato, salad, fruit and beverage, all for less than two dollars.

Winnie hired her mother, Rosa May Harmon, as head of the housekeeping department. She lived in the hotel, which her traveling salesman husband would visit two days per month. He drank whiskey out of a flask disguised as a pair of binoculars.

Guests paid eight dollars per night for the best rooms. In order to create some type of change, Bill planned to paint the exterior of the hotel white. Instead of following through, change came in another way—the roof fell in.

On November 1, 1959, snow from a wet and heavy storm cracked some of the panes in the rooftop skylight, and chunks of glass fell to the stained-glass ceiling below. Two of those panes, part of the original leaded cathedral glass imported from Italy in 1908, crashed into the lobby below.

Then, as if everything were fated to happen at once, William Hutson Sr. died at the age of seventy-nine. Son, Bill Jr. followed him just four months later from an overdose of insulin at the age of fifty.

Winnie oversaw the removal of the original stained glass and its temporary replacement with red, white and blue plexiglass. She then married her contractor, sold the hotel and moved away from Boulder.

The Hutson years were over. Of the condition of the hotel at the time, manager Ralph Hume simply stated, "The bloom was off the rose."

Lefferdink Left Empty Pockets in Boulder

Throughout the 1950s, insurance tycoon and financier Allen J. Lefferdink built up a bogus multimillion-dollar empire based on worthless securities. Then his schemes—like those of Bernard Madoff and other con men—collapsed.

Financial wheeler-dealers are nothing new, but Lefferdink's initial companies were based in Boulder, and many of his clients were left with empty pockets.

In 1949, when thirty-one-year-old Lefferdink founded the Colorado Credit Life Insurance Company, the press called him a "youthful financial wizard." Before long, he controlled at least forty corporations and employed 3,800 agents, who quickly spread his concepts of postwar consumer credit throughout the country.

What Lefferdink offered was one-stop shopping for insurance, savings, loans and investments. If, for instance, one of his companies financed a car, then another company would handle the car insurance, but not before a few dollars were tacked on for credit life insurance and savings.

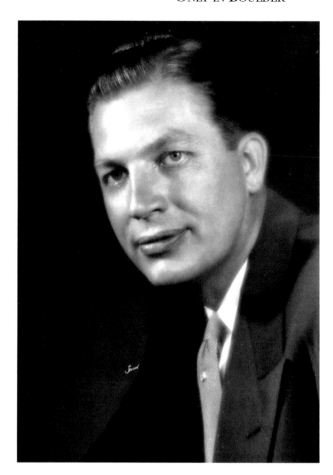

Allen J. Lefferdink was a super-salesman in the post–World War II era, but in Boulder he's remembered as a swindler. *Courtesy of the Daily Camera.*

The companies were underwritten by stocks—purchased on the installment plan. Inter-company stock transactions were frequent, as Lefferdink shifted bank balances from his more lucrative companies to others in need of funds.

According to the *Boulder Daily Camera*, Lefferdink only sold to Colorado residents so that he would not have to register the sales with the U.S. Securities Exchange Commission. Innocent investors often discovered that when they wanted to pull out their money, it simply wasn't there.

The beginning of the end for Lefferdink came in September 1960, when a civil suit in Denver District Court alleged twenty-seven manipulations in stock, notes and advances between defendant corporations. Lefferdink tried to reorganize as the Allied Lending Corporation, but his new enterprise never got off the ground.

Also contributing to his downfall were more than $100,000 worth of mechanics liens filed against the construction of a hotel, partially built and since torn down on the site of today's Boulder County Justice Center.

When a Texas firm acquired Colorado Credit Life, the transaction included the nine-story Colorado Insurance Group Building at 1919 Fourteenth Street. Lefferdink had constructed it four years earlier. It was complete with penthouse offices and a rooftop heliport, but he could not keep up with the payments.

The building also came with a restraining order against Lefferdink, who had been accused of threatening to destroy company records after intermingling Colorado Credit Life assets with those of his other corporations.

In 1961, a federal grand jury indicted Lefferdink for fraud and conspiracy in bilking twenty thousand investors out of more than $15 million. He managed to be acquitted, but on his way out of town, he told a reporter, "I came to Boulder broke, and I suppose some people would find it amusing if I had to go out the same way."

Lefferdink then went to New York, where he set up a string of international businesses and established a pyramid of banks, mutual funds and insurance companies. Finally, he moved offshore—onto his yacht *Sea Wolf*—but sailed into Miami where, in 1976, new fraud and conspiracy charges did bring a conviction.

Eventually, Lefferdink was sent to jail. He died in 2003, leaving a legacy as a super swindler.

Boulderado Guests Urged to "Eat with Fred and Sleep with Ed"

During the years between the Hotel Boulderado's elegant early days and its more recent upscale restoration, Boulder's first large downtown hotel was inexpensive and homey. In the 1960s, many of its guests were permanent tenants who spent their evenings sitting around a solitary television in the lobby after having eaten at Fred's Steakhouse, then located in the hotel's main dining room.

In 1961, the late Ed Howard leased (and, a year later, purchased) the five-story brick building at Spruce and Thirteenth Streets. In order to

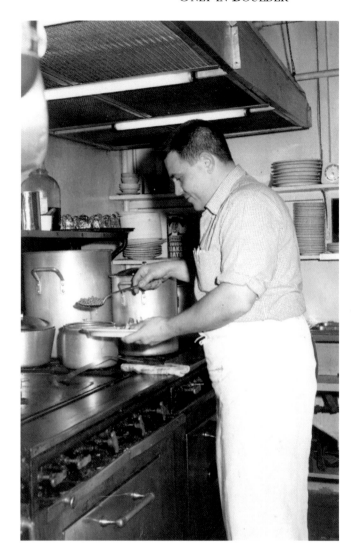

Fred Shelton operated several Boulder restaurants, including Fred's Steakhouse in the dining room of the Hotel Boulderado. *Courtesy of the* Daily Camera.

comply with the city's fire code, he retrofitted the hotel with sprinklers. He also rented the dining room—now Q's Restaurant—to Fred Shelton, who quickly became famous for his $2.15 sirloin steak dinners. Before long, a newspaper columnist urged his readers to "eat with Fred and sleep with Ed."

Although some hotel tenants illegally cooked on hot plates in their bedrooms, most of the guests were regulars in the dining room. Penniless Mr. Lawry—no one called him by his first name, Walter—would "charge" his meals. At the end of every month, a coffee group chipped in to pay his

bills. It also wasn't unusual for tenants and others to order hot water, add some free catsup and crackers and leave without paying anything at all.

Shelton—as well as Howard's wife, June, and son, Joe—remember several of the Boulderado's colorful characters. Most were elderly and had no family. "The tenants were individuals, and they preferred their own separate tables," said Shelton who ended up as a pallbearer at several of their funerals.

Joe Howard was a young boy at the time and, after school, would hang out in the hotel lobby. He remembers it smelling like perfume, with ladies who stopped long enough from their crocheting to entertain him with a game of cards.

One of the women was Katherine Parker, who claimed to be the widow of a "general." She lived in the hotel until she died and left behind several trunks of vintage clothing. Another tenant, named Olive Corwin, taught the young Howard some magic tricks. Shelton remembers Corwin as "a tiny gal, a sweetie."

Shelton also remembers Pat Katsura, who spent his time trying to accelerate the germination of grass seed. "When he finally moved out," said Shelton, "seeds were growing out of everything—even the rug."

"Mrs. Hanks," a Texan who wore large hats, used to give Shelton a hard time about a cartoon character called "Box Car Freddie" that he used in the restaurant's advertising. June Howard remembers Hanks as saying, "This tramp character is not the sort of person one wishes to have patronizing the dining room."

Elizabeth Selleck, a retired reference librarian at the University of Colorado, also lived at the hotel, as well as retired hard rock miner Fred Dopp. Once a month, Dopp would deposit a whiskey flask of gold dust in the hotel safe.

Hotel rooms at the time ranged from $4.50 to $6.00 per night, with lower monthly rates for tenants. "Even so," said Joe Howard, "my father had a suitcase of watches from people who couldn't pay their bills."

HELEN GILMAN'S HANDICAP A PSYCHIC GIFT

Helen Gilman was a Boulder County native who read tea leaves and told fortunes for seventy-five years. Deaf from a bout with typhoid fever as a child,

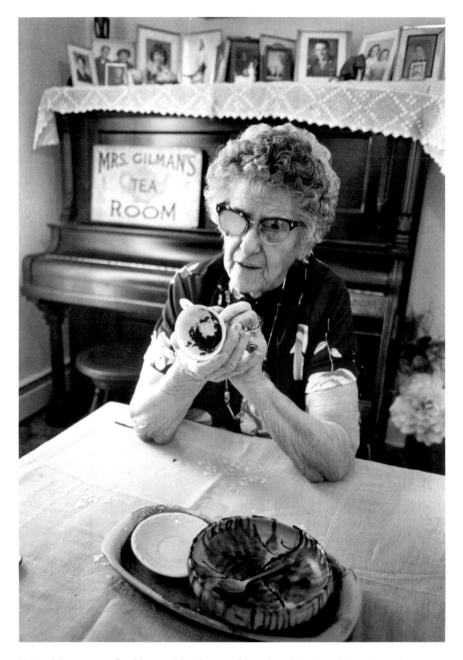

Helen Gilman was a Boulder psychic who tuned in to her clients' problems by reading tea leaves. *Courtesy of the* Daily Camera.

she was considered different from her peers. She later explained that her deafness had given her a second sight. As an adult, she used her handicap—which she considered a psychic gift—to help others with their problems.

Gilman was born in 1892 as Mary Helen Sherman. She grew up in the Boulder County mountain town of Jamestown, where her grandparents ran the Martins Hotel and her father, Wella Sherman, worked at the Golden Age Mine.

According to Gilman's biography (*Helen: A Psychic Gift*, now out of print), she learned early on to follow her instincts. She claimed to have known intuitively how to escape uninjured when a circus tent in Boulder collapsed on an unsuspecting audience.

In another instance, while riding in a stagecoach from Jamestown to Boulder, Gilman slipped under the seat just before an accident killed another passenger. She learned to read tea leaves by accompanying an adult friend who performed the ritual for friends and neighbors.

At age twenty-five, she married John Gilman, a Boulder taxi driver.

Before long, the young woman was in demand at sorority and fraternity parties, where she dressed like a gypsy and amused University of Colorado students by telling their fortunes.

Gilman also opened the Ye Old Tea Room, located for more than six decades in her home at 624 Concord Street. She always began her readings with a fresh cup of loose black tea. Then she'd set the cup on a card table and instruct her clients to drink it while intonating, "The tea is bitter and so is life."

When her clients finished drinking their tea, Gilman patted the remaining tea leaves with a spoon and placed the teacup upside down on a saucer. The person seeking information was asked to turn the cup three times and make a wish. Almost immediately, Gilman, adept at lip-reading, would speak rapidly in a husky voice and give personal advice on topics such as jobs and relationships.

The answers to one's problems, Gilman told her clients, lay in pictures that she saw in the leaves that remained in the bottom of the teacup. She admitted, however, that the tea was really just a medium to help her meet and talk with people.

Gilman was said to have radiated happiness and peace from within. In an interview shortly before she died, she told the authors of her biography, "I try to help people learn to listen better to their inner voice."

Throughout the years, she increased her fee from twenty-five cents to five dollars, and her guest book grew to more than eighty thousand signatures. Gradually, cataracts in her eyes left her nearly blind. She died of cancer in 1985 at the age of ninety-two.

Gilman always concluded her readings the same way. "If none of this is true," she said, "at least you've had a cup of tea."

Harrison Cobb Preserved County's Mining and Milling History

In the late-1920s, Harrison Cobb was a Florida college student aiming for a career in Romance languages, but he lost interest as soon as he read national magazine articles about gold mining in the West. By 1931, he and some friends opened a gold mine in the town of Sunset, in Four Mile Canyon, west of Boulder. "The gold wasn't there," he said, "but I got my first experience, which was what I was after."

Cobb prospected and mined for fifty years, and then he started a new search to find the sites of the mills that processed Boulder County's precious metals. His work resulted in his book, *Prospecting Our Past: Gold, Silver, and Tungsten Mills of Boulder County.*

During the days of the Great Depression, Cobb dug around in the darkness of the mines for weeks on end. When he did spend an occasional day out in the sunshine, he began to "clean up" some of the then abandoned gold mills.

"Like most other businesses, mills that grind and concentrate gold ore eventually cease operations," said Cobb. "The mine may have run out of ore, or the price for the product could have declined to the point where the operation was uneconomical. In such cases, few of the operators bothered to make a final cleanup."

Cobb saw opportunities to make what he called "easy money." After striking a deal with the owners, Cobb swept the mill floors and then carefully scraped and shoveled the fine residues that had collected beneath the floorboards and around the foundations. He loaded the salvaged product into railroad cars and shipped it to the Golden Cycle Mill at Colorado Springs.

Harrison Cobb signed copies of his book *Prospecting Our Past* at the Boulder History Museum. *Photo by the author.*

Over a period of time, Cobb's search for dollars was converted into a search for the mills themselves. He feels fortunate to have had mentors—the old-timers of the 1930s and 1940s, who not only taught him to mine but also conveyed the history they had learned from those who came before them.

In 1983, Cobb decided to see how many of the old mills he could find. After library research turned up photographs of more than one hundred different mill buildings, Cobb, at the age of seventy-five, set out with a camera to see what was left. Although only a handful of buildings remained, he was able to document the current locations of most of the mill foundations.

"It became obvious that information and facts about this important era in our local history were disappearing so rapidly that it was essential to capture and record it while much of it was still obtainable," he said.

His historical detective work combined mine records, newspaper reports and 190 historical and current photographs. In the foreword to Cobb's book, author and historian Duane A. Smith explains, "To tell the saga of mills and smelters takes a rare combination of technical knowledge, experience, persistence, and a love for tracing the faint history of successful and

unsuccessful industrial operations. Without question, the author abundantly possesses these attributes."

Cobb has no regrets about the past. "My heart's in prospecting," he said. "It's more fun than anything. You're always looking for buried treasure, and now and then you find it."

Unusual and Legendary

HORACE AND BABY DOE'S BOULDER COUNTY YEARS NEARLY FORGOTTEN

Articles, books and even an opera ("The Ballad of Baby Doe") have been written about Horace and Baby Doe Tabor, but few of these sources mention the Tabors' years in Boulder County. The legendary "Silver King" lost a fortune with his beautiful mistress turned wife Baby Doe at his side. Near the end of his life, Horace undertook several mining ventures in an attempt to recoup his fortune. The Eclipse Mine north of the mountain town of Ward was his final try.

Tabor was originally a stonecutter who left Vermont for Colorado with his first wife, Augusta, during Colorado's gold rush in 1859. After striking it rich in Leadville, he divorced Augusta and married Baby Doe in an extravagant Washington, D.C., wedding while serving a thirty-day interim term as U.S. senator.

At first, life was good for the recently wed couple. Their first daughter, Lily, was christened in a $15,000 dress. An expensive diamond adorned her diaper pin. The family enjoyed a lavish lifestyle in Denver, where residents often spotted them in a coach pulled by four horses in gold harness.

Still reaping the wealth of Leadville, Tabor diversified his investments with timber holdings and opera houses. By 1888, he also controlled the

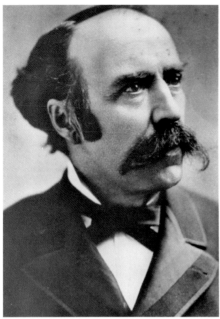 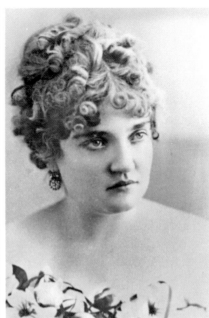

Horace and Baby Doe Tabor tried, and failed, to recoup their losses by searching for gold in the Eclipse Mine in Boulder County. *Courtesy of the* Daily Camera.

Poorman Mining Company in the town of Caribou near Boulder County's western boundary.

As the price of silver plummeted, Tabor's luck began to run out. When daughter Silver Dollar was born in 1889, Tabor's fortune was quickly fading. Then the silver market crashed in 1893, and he became overextended and deeply in debt.

In the summer of 1897, Tabor turned to his old friend Winfield Scott Stratton, who had made his fortune mining gold in Cripple Creek. Stratton loaned Tabor $15,000.

The Ward newspaper at the time noted, "Tabor moved with his family to a little lone cabin on the hillside some four miles from camp [Ward] and began again to work out his fortune in the same pursuit in which he first became famous in the state."

A reporter noted that the sixty-seven-year-old Tabor was seen in Ward every few days. Baby Doe, then age forty-three, had to readjust to life without gowns and jewels. Lily and Silver Dollar were twelve and seven years old.

Tabor never repaid Stratton's loan. Instead, he spent a discouraging year and did not find much gold. In 1898, he was offered the position of postmaster of Denver.

"Since his arrival in Boulder County last summer," stated the reporter, "the ex-senator has become a familiar figure in Boulder and Ward, and the people take an exceptional pride in his appointment."

Tabor's job did not last long. In 1899, he died from appendicitis. He lay in state in the capitol building, where he was surrounded by mourners and bouquets of flowers.

Baby Doe was left practically penniless. She moved to Leadville, dressed in rags and lived in a crude cabin next to her last possession, the Matchless Mine. In 1935, she was found frozen to death. The Eclipse Mine, now on private property, never produced any significant amount of gold and has long been forgotten.

CHARLES CARYL'S UTOPIAN DREAMS FOR WALLSTREET NEVER MATERIALIZED

Charles Caryl was a self-described social planner, but in Boulder County he was simply a con man. In 1897, he arrived on the scene as a mining company promoter, professing dreams of a utopian community. He bought sixty gold mining claims in the Four Mile Canyon town known as Delphi and then renamed it Wall Street for New York's financial district. The name ("Wallstreet" today) stuck, but the utopia was never more than an idea on paper.

With money duped from eastern investors, Caryl's Wall Street Gold Extraction Company mined gold from the Nancy group of mines. In 1902, in his newly constructed mill, Caryl began to process the ore into gold bullion. But the impressive chlorination operation only ran for two years. Caryl also built a store, an assay office and a large boardinghouse for miners.

In the planned community, each man and woman would produce to the utmost of his or her ability, and the workers would be remunerated according to their contributions. There were to be seven classes. Recruits would shovel dirt, handle freight and do light factory work and housework. Pay for an eight-hour day would be two dollars.

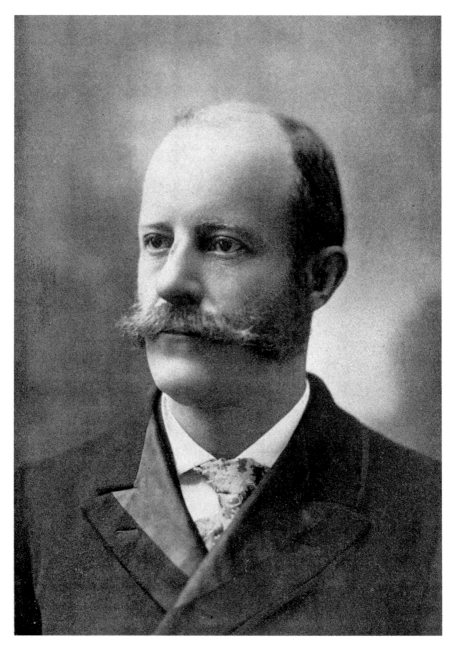

In his book *New Era*, Charles W. Caryl called himself "one who dared to plan." *Courtesy of the author.*

According to Caryl's book *New Era* (self-published in 1897), "privates" earning three dollars per day would do work "requiring some experience and ability." Next would be "sergeants"—"skilled mechanics, accountants, teachers, musicians, and salesmen and saleswomen," who each would make four dollars per day.

"Lieutenants" would be professionals who would earn six dollars per day. "Captains," at ten dollars per day, would be "expert lieutenants," and "majors," to be paid fifteen dollars per day, would be "general managers and chiefs of various departments." Finally, there would be one "general," Caryl himself, who would earn twenty-five dollars per day.

Things didn't go well for Caryl. With attorneys and creditors at his heels, he moved to Denver and established a cult called the Brotherhood of Light. According to the *Boulder Tribune*, the organization's stated purpose was the education of waifs. However, Caryl, as the cult's leader, was accused of starving to death thirteen young children.

Caryl then moved the Brotherhood of Light to California, where he was reported to be "working out the problem of a higher civilization through the perfection of the sexes." Meanwhile, in 1907, the mill (described by one reporter as an "enormous monument of folly") was sold in bankruptcy proceedings. Its buildings were dismantled, and the machinery was moved by train to the Livingston Mill near the community of Sugar Loaf.

In 1912, a United States deputy marshal transported Caryl from San Francisco to a Denver jail and charged him with sending "obscene matter"— probably then illegal birth control literature—through the mails. Caryl also was credited with inventing a substance known as "Vril," which he claimed "was a panacea for all the ills and also capable of destroying the strongest army."

The assay office, long used as a residence and now owned by Boulder County, still remains in Wallstreet, and the mill's large stone foundation towers over the quiet residential community today. But long ago, Caryl's shady schemes faded into the past.

TOM HORN'S A STAR IN "MEET THE SPIRITS"

When Wyoming outlaw Tom Horn's twenty-seven-year-old niece, already in failing health, heard the news that her uncle would be hanged, she breathed

Posthumously acquitted outlaw Tom Horn was born in 1860, even though his gravestone reads 1861. *Photo by the author.*

her last gasp and died. She was buried at Columbia Cemetery, never knowing that Horn would be buried near her or that he had been wrongly accused.

Every other year, on a Sunday afternoon in October, Horn and more than thirty other characters come to life. The "Meet the Spirits" reenactment takes place at Boulder's Columbia Cemetery, at Ninth and Pleasant Streets, and is hosted by Historic Boulder, Inc. Proceeds aid in cemetery preservation, and the self-guided tour is a fun way to learn about Boulder's past.

In 1903, shortly before Horn's forty-third birthday, the hired gunman was arrested and accused of killing a fourteen-year-old boy. In a Cheyenne, Wyoming jail cell, Horn professed his innocence. Then, ten minutes later, according to the *Boulder Daily Camera*, he was "hanged by the neck until dead."

Horn never lived in Boulder, but his brother Charles Horn did, so Charles arranged for Tom's body to be brought to Boulder for a proper burial. A Denver man offered Charles $5,000 for his brother's body, intending to put it on display. A reporter noted that Charles "scornfully refused."

Quoted in a subsequent article, Charles stated, "We buried Tom with all due respect that relatives and friends could show." Tom Horn's funeral was

private, but many Boulder residents accompanied his body to the cemetery. Charles's daughter (Tom's niece) had already been interred, and Charles would follow twenty-seven years later in the same family plot.

While Charles Horn was driving a horse-drawn wagon for Boulder's Crystal Springs Brewery, brother Tom's occupations had included trapper, hunter, teamster, government scout, interpreter and range detective—hired by the Wyoming Stock Owners Association to rid the area of cattle rustlers.

At the time, the family of the boy Horn was accused of killing had brought sheep into predominantly cattle country. Tensions between cattlemen and sheep ranchers were almost as strained as between cattlemen and rustlers.

The boy—mistaken on his horse for his father—apparently was shot by a feuding neighbor, although Horn had, admittedly, shot other men. There were no witnesses, but the trail initially led to Horn because a flat rock had been placed under the boy's head. Horn had used such a symbol to identify his victims so his employers would pay him for ridding the area of another rustler.

In 1993, Horn received a posthumous acquittal during a reenactment of his trial in a Cheyenne courtroom.

George Russell, the "Meet the Spirits" actor who portrayed Horn in the past and will do so again in the future, said, "I appreciate the predicament in which he found himself—caught between the culture of the Old West and the emerging changes of the new Old West."

Added Russell, "Horn was a man of his times who played by the rules of the Old West but was trapped in the crack when the rules changed."

HEINRICH PREFERRED DETECTIVE WORK TO GOVERNMENT

Edward O. Heinrich was Boulder's first city manager, but his heart wasn't in his job. Before he went to Boulder in 1918, he had been chief of police in Alameda, California. After he left Boulder, he taught criminology at the University of California–Berkeley. Called the "Wizard of Berkeley" and "America's Sherlock Holmes," he spent most of his life as a detective.

The city manager form of government was a nationwide trend when it was adopted by Boulder residents in November 1917. After voters chose

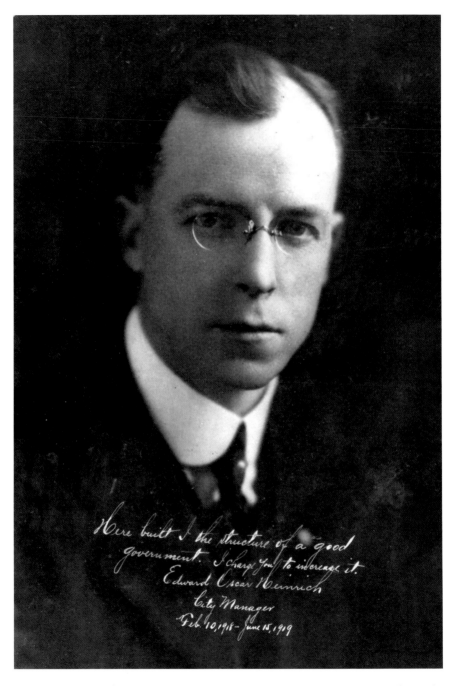

Although City Manager Edward O. Heinrich's inscription was about government, he much preferred working as a detective. *Courtesy of the* Daily Camera.

nine city council members, the search was on for a city manager. Heinrich was picked from more than one hundred candidates.

Although he had many duties, Heinrich's main interest was the Boulder Police Department. He announced that he intended to "enforce city ordinances, cooperate with law enforcement agencies and maintain complete records of arrests and complaints."

Not much is known about Heinrich's actual accomplishments in Boulder. According to the *Boulder Daily Camera*, he increased water rates and started a "constructive program of public safety." However, after just sixteen months on the job, he resigned amid allegations of criticism.

A newspaper editorial treated his departure delicately by noting that "some of his acts will always be a subject of dispute as to their wisdom." The *Daily Camera* wished him well "regardless of past differences," and the editor stated that Heinrich's position in California would be "fuller of opportunity for recognition and reward."

Apparently, the former city manager did not harbor ill feelings against Boulder, as he continued his ties with the police department. In 1924, a man named Norman Drake was accused of being the "hit man" in the murder of police officer Elmer Cobb. The district attorney tried, unsuccessfully, to obtain a confession by injecting the suspect with "truth serum," sent from California by Heinrich.

Although he didn't solve the Cobb case, Heinrich solved a California murder by examining the handwriting on a ransom note and determining that the writer "had the hand of" a cake decorator. His uncanny forensic abilities also resulted in the capture of three brothers whose murderous rampage on a mail train resulted in a massive, and successful, manhunt.

In 1930, Heinrich stopped in Boulder on his way to visit Scotland Yard in London. He and his wife were shown around town by then city manager George Teal and honored at a dinner at the Boulder Country Club. Of the Heinriches' visit, a reporter noted that "they were enthusiastic in their praise of Boulder's development during the last eleven years."

Heinrich again came to Boulder in 1949, following the murder of University of Colorado student Roy Spore. But even the famous detective couldn't find a clue, and the Spore case remains unsolved to this day.

By the time of Heinrich's death at age seventy-two in 1953, he was credited with having solved two thousand cases. None of them were in Boulder, but

he did leave behind some colorful quotes. When he left the city manager's position, he told his colleagues, "One's country may inspire one to die for it, but a municipality is scarcely worth the supreme sacrifice."

BYRON WHITE WAS CU's FAVORITE SON

At a University of Colorado football game, a sports writer noted that Byron White "seemed to whiz by people." Before long, the star player had became known as "Whizzer." Now deceased, the Colorado-born athlete and scholar never slowed down until he had served three decades in the U.S. Supreme Court. He excelled both on and off the field, continuing the pattern throughout the eighty-four years of his life.

"Byron is the ideal athlete," wrote the athletic editor of CU's yearbook in 1938. "A more modest and unassuming young man there never was. But above all these achievements stands Byron himself, a man of strong character."

Byron "Whizzer" White excelled on and off the football field. *Courtesy of the* Daily Camera.

White grew up in the small town of Wellington, near Fort Collins. As a child he worked in the sugar beet fields and then helped his father, who owned a lumber yard. After a public school education, White entered CU as an economics major and played basketball and baseball, as well as football.

At the close of the 1937 football season, CU's team was untied and unbeaten. On New Years Day 1938, the newly named Buffaloes played Rice University in the Cotton Bowl in Dallas. Even though CU lost the game, White was considered the most popular football player in the country. Stated a reporter, "He was as glorious in defeat as he had been in victory."

The following spring, White graduated first in his class of 1938, of which he was president. He had earned a Rhodes scholarship to England's Oxford University, but he postponed his graduate school education to sign on with the Pittsburgh Steelers.

The next year, White did begin his law studies at Oxford, but he returned to the United States, where he entered Yale Law School. Then he interrupted his education again to earn his tuition by playing for the Detroit Lions. Fellow players remembered him leaving practice with his law books under his arm.

Although his professional career lasted just three seasons, he was named to the National Football Hall of Fame.

White became a naval intelligence officer in World War II and then returned to Yale and graduated magna cum laude in November 1946. That same year, in Boulder, he married Marion Stearns, daughter of then CU president Robert Stearns. After a year in Washington, he practiced law in Denver for fourteen years.

In 1962, President John Kennedy chose White as his first Supreme Court nominee. White was known to back strong law-and-order decisions and cast votes sympathetic to the civil rights movement. He retired in 1993 and was replaced by Justice Ruth Bader Ginsburg.

CU hasn't forgotten its favorite son. White was the inaugural inductee in the CU Athletic Hall of Fame. His jersey, no. 24, is on display with photos and other memorabilia in the Heritage Center Museum on the third floor of Old Main on the CU campus.

A reporter once called White a "warm guy with a good sense of humor" and added that he didn't care for the spotlight. Apparently, he didn't care for "Whizzer" either. Whenever his secretary was questioned on its spelling, she was told to respond, "B-Y-R-O-N."

PLANE BOMBER EXECUTED FOR MOTHER'S MURDER

On November 1, 1955, John Gilbert Graham packed twenty-five sticks of dynamite and a timer into his mother's suitcase before she boarded a United Airlines flight at Denver's Stapleton Airport. Bound for Portland, Oregon, the plane blew up near Longmont, in eastern Boulder County. The blast killed all forty-four passengers and crew members on board.

Graham was convicted of first-degree murder in the death of his mother. Fourteen months later, in January 1957, his life ended in the gas chamber at the Colorado State Penitentiary. Denver newspaper writer Zeke Scher led the way in reporting the clashes and conflicts between Graham and his mother, Daisie King. The troubled relationship lasted to the very end of Graham's life, when he told witnesses at his execution, "I will see my mother tonight."

Andrew J. Field, author of *Mainliner Denver: The Bombing of Flight 629* (Johnson Books, 2005), also acknowledged Graham's grievances against King but emphasized that they in no way justified murder.

The mother-son problems started when Graham was quite young. His father had died when the boy was five years old, and King supposedly was unable to care for him. She kept her daughter, but she placed her son in a Denver institution for fatherless boys.

When Graham was nine years old, King married a prosperous Routt County rancher. But instead of bringing her son home to live with her, King left Graham in the institution.

The following year, at Christmas, Graham was allowed to visit in his mother and stepfather's home, where he was led to believe he would be allowed to stay. But as soon as the holiday was over, King sent Graham back to the boys' home.

From then on, Graham had troubles with the law, including bootlegging, carrying a concealed weapon and check forgery. When he left the institution, he joined the U.S. Coast Guard, but he went AWOL and was deemed "unsuited for service" at his court-martial.

In 1953, Graham married and started a family. King's husband had died, leaving her a wealthy widow. She bought the newlyweds a house and fixed up a room for herself in the basement. She even bought Graham the "Crown-A," a drive-in restaurant, and made him manager. But the tension between mother and son mounted as they argued over who was boss.

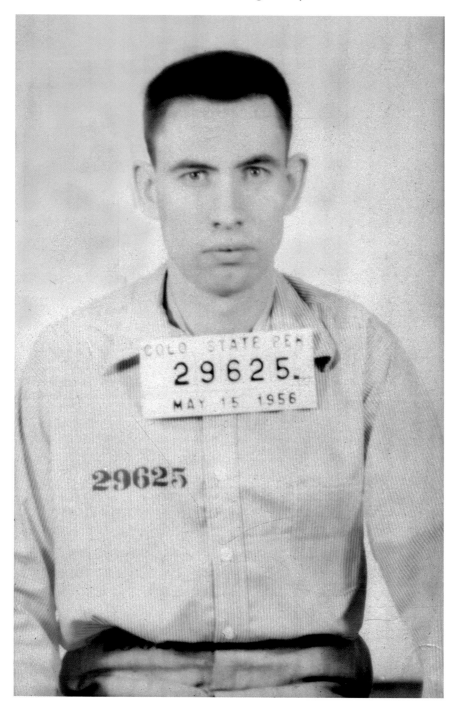

John Gilbert Graham was executed in January 1957 after the plane he sabotaged blew up over beet fields near Longmont. *Courtesy of the Colorado State Archives.*

On the night of the first-ever sabotage of a passenger plane, Graham and his wife accompanied his mother to the airport. When her baggage was found to be overweight, Graham convinced King to pay an extra charge to take all of her luggage. He then plugged a few quarters into a vending machine to purchase a $37,500 insurance policy on her life.

Before his execution, Graham invited Scher to sit on his lap while he was blindfolded and strapped to a chair. The reporter declined. A stethoscope was strapped over Graham's heart, and a tube was extended through the wall of the gas chamber to a doctor, with earphones, outside.

The execution took approximately ten minutes, just one minute less than the time King and the rest of the passengers and crew were in the air.

DUMMY MUM ON CANYON PRANK

In April 1955, motorists in Boulder Canyon screeched to a halt and then sped to Boulder to report the "body" of a man suspended from a wire thirty feet over the road in Boulder Canyon. University of Colorado students were suspected of the prank, but no one ever confessed and no one was ever caught.

Boulder County deputy sheriff Dale P. Goetz Sr. rushed to the scene, about a mile and a half up the canyon. According to the *Boulder Daily Camera*, Goetz managed to "rescue" the life-size dummy—made of rags and papers stuffed into a yellow sweatshirt and blue-gray trousers. A crude face was painted on a stuffed paper sack "head," which was topped off with a red cap with a visor.

A few days after the incident, the newspaper ran a photo of Sheriff Arthur T. Everson attempting to shake hands with the dummy, although if it ever had hands or feet they must have fallen off. The caption read, "The prisoner won't talk." The writer obviously was someone with a sense of humor, as he added that the sheriff "couldn't get a word out of this guy."

Another photo, circulated by a national news service, showed Goetz standing next to the dummy, seated on a desk in the Sheriff's Office. At the time, the seven-man department was located on the first floor of the Boulder County Courthouse on Pearl Street. The caption for that photo, which ran in an unidentified publication, was titled "Tain't Funny."

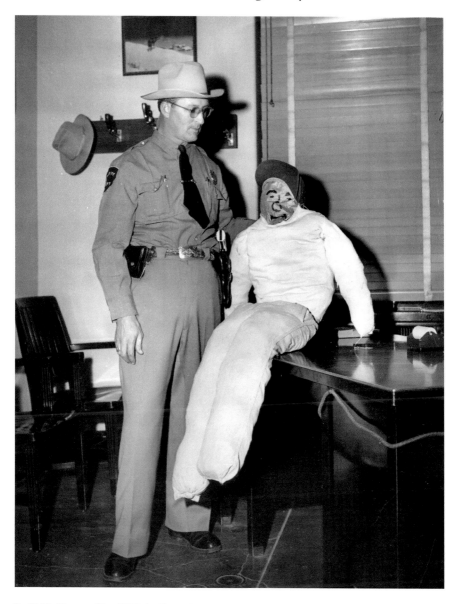

In 1955, Deputy Sheriff Dale Goetz Sr. posed with a dummy that was strung on a wire over Boulder Canyon. *Courtesy of the author.*

If CU students were responsible for the stunt, they must have had a lot of time on their hands and may have been aspiring engineers. The dummy was rigged with what the reporter described as "an ingenious network of wires and pulleys." The main wire was stretched above the road from one side of a deep rock cut to the other and was attached to rocks on either side.

The prank began after dark. The dummy was rigged so that the "body" showed up in the headlights of cars going up or down the canyon. Although traffic was lighter half a century ago, the roadbed in this lower part of the canyon had been raised from the creek and reconfigured in 1953, making it essentially the same today as it was when the prank was performed. Boulder Canyon is still the main road west out of Boulder.

At first glance, motorists saw the dummy hanging over the middle of the road, but whenever a driver stopped to investigate, the operator or operators of the pulley suddenly moved the "victim" to the side, where it disappeared from view.

When Goetz retrieved the dummy, he cut down the wires and put them in the Sheriff's Office's first patrol vehicle, a 1949 Jeep. Goetz searched the canyon and adjacent mountainous area for the perpetrators, but they either were experienced climbers and managed to vanish or they were clever liars. The *Daily Camera* noted, "The officer found no one around who would admit any knowledge of the affair."

ASTRONAUT'S MOTHER TREATED AS A CELEBRITY

Hometown hero Scott Carpenter achieved national fame in May 1962 when he became the second American to orbit the Earth. While he was in outer space, his mother, Florence Carpenter, was at home in Boulder waiting for news of his safe return.

A media frenzy began with press conferences a week prior to liftoff, and Florence was interviewed extensively. A typical *Boulder Daily Camera* headline read, "Astronaut's Mother Is Keeping Calm." Florence told reporters, "The magnificence of the experience he is going to have is so great that it would erase any apprehension I might have."

Privately, however, she had a mother's concern for her son. At the same time, other people were watching out for her. On the day of the flight,

Boulder resident Florence Carpenter holds a photograph of her astronaut son, Scott Carpenter. *Courtesy of the* Daily Camera.

Sergeant Gaynor "Tiny" Walker and Patrolman Harold See of the Boulder Police Department were given the job of guarding the astronaut's mother.

According to See, she needed protection in case her son became so much of a hero that his mother would be held for ransom. To avoid an

onslaught of photographers, Florence spent the night before the flight at Boulder Community Hospital, where she was head of the medical records department. At 4:30 a.m., the two policemen drove her to her home in their patrol car.

The police officers shared coffee with Florence while she secluded herself with three family friends in the Mapleton Mobile Home Park. Besides her own television set, two other sets were installed for the day so that they could watch all three networks at once.

Outside, the scene was chaotic. In the pre–satellite dish days, the local telephone company spent a week setting up a looming television tower so that the three network stations could broadcast from her home.

On the day of Scott Carpenter's flight, NBC, CBS and ABC reporters huddled outside his mother's home, waiting for a glimpse of her and ready to record every word. The liftoff, she told them, was the most exciting moment, and she admitted to feeling anxious and tense during the capsule's reentry.

The astronaut's mother's words were relayed from the trailer park's makeshift tower to another temporary tower at the University of Colorado. There, NBC set up a nine- by twelve-foot screen. From CU, the broadcasts were relayed to Denver for transmission all over the country and overseas.

Florence's first official words after her son's successful splashdown were, "Today we have seen [the] courage, determination, dedication and power of the United States, and we know now why we shall never be buried." She added that his landing was the happiest moment of her life. Only then did she step outside into the glare of the television cameras before being escorted to a news conference at CU.

"I felt great patriotism," said Patrolman See, now retired and living in Texas. "Mrs. Carpenter gave me two plastic piggy banks in the shape of space capsules for my children in return for my staying with her. My son still has his."

After Carpenter's historic flight, the city of Boulder gave its native son a welcome home ceremony, temporarily displaying a model of his Aurora 7 Mercury spacecraft on Pearl Street in front of the Boulder County Courthouse.

ELLENOR HACKER TOOK OUT THE TRASH AND DISAPPEARED FOR ELEVEN YEARS

A half-century ago, in December 1959, Ellenor Hacker, a fifty-five-year-old widow, disappeared when she left her Boulder home at 6:30 a.m. to take out the trash. Eleven years later, a member of the Boulder Police Department found her in Victoria, British Columbia. During the intervening years, no one—not even her family—knew where she was.

For eleven years, Ellenor Hacker got away with a new name and identity. *Courtesy of the* Daily Camera.

Initially, her sisters and grown children suspected that she had been murdered. Hacker, who worked as an insurance underwriter, was believed to have been wearing a pink nightgown and bathrobe, leaving the back door open and her purse and glasses behind. However, missing from the Arapahoe Avenue and Twentieth Street home that she shared with her son and daughter was $350 from a recent stock sale.

"You fellows keep trying to make a homicide out of this," Boulder police chief Myron Teegarden told a newspaper reporter at the time. "As far as I'm concerned, Mrs. Hacker is still a missing person until we have something more to go on."

The police interviewed relatives and friends, who were united in their belief that Hacker was "a very stable, efficient, and forceful woman." No one could think of a reason why she should drop from sight. Her daughter added that she had been baking fruitcakes and cookies and was planning for the upcoming Christmas holidays.

Two weeks after Hacker's disappearance, Chief Teegarden mailed five hundred missing-person circulars, with her description as a short, heavyset woman, to state police all over the country and to numerous large city police departments.

As it turned out, Hacker did leave voluntarily, citing family problems. She assumed a different name and lived in San Francisco, where she worked as a housekeeper for an invalid woman and then a nurse before retiring and leaving the country.

The Boulder police were tipped off when she applied for Social Security benefits. That led them to her San Francisco address, where they questioned her former landlady, who recognized the missing woman's photograph. From there, the police followed her trail to a one-room apartment in Canada. When confronted, she admitted that she was the missing person they had been seeking.

According to a reporter who interviewed Hacker in 1971, she was "furious" with the Social Security Administration for giving her information to the police. She admitted that she had tried to make her disappearance as intriguing as possible because she "liked mysteries."

A spokesman for the police department, which had worked for years to find her, said that Hacker "had a moral obligation" to contact them and admitted that the cops didn't even want to think about her case

again. When the news broke, she reluctantly reunited with some of her family members.

In her newspaper interview, Hacker finally filled in some gaps on her disappearance. She said that she had purchased a new dress and handbag the day before she left and took only a toothbrush, hairbrush and a one-way train ticket to San Francisco.

"I've had a happy, busy life, and a useful one," she stated at the time. "There wasn't any quarrel—I just left. I had a little money saved, and I just thought 'the heck with it.'"

"Lonesome Cowboy" Tried to Marry His Horse

Boulder has long been known as a haven for animal lovers, but in 1975 one local man lent a whole new meaning to the term "animal husbandry."

Roswell "Ros" Howard made national news when he applied for a marriage license to wed his horse. According to Howard's own account, in an unpublished manuscript titled "Dolly and Me," the license was refused because the bride was only eight years old and couldn't provide consent in writing from her parents.

Howard made it clear that his intent was to interject "a mark of sanity in a world where apparently madness was viewed as rational behavior." He was referring to the actions of then Boulder County clerk Clela Rorex, who for a brief period of time issued marriage licenses to same-sex couples.

In order to make his point, the sixty-three-year-old Howard obtained a parade permit from the city so that he could—in Boulder's pre–pedestrian mall days—park Dolly and his horse trailer on Pearl Street directly in front of the courthouse. The Boulder Police Department promised to provide traffic control.

With Bob Palmer, television reporter for CBS news, standing by, Howard entered the courthouse in April 1975. He was quoted as asking, "If a boy can marry a boy and a girl can marry a girl, why can't a lonesome old cowboy get hitched to his favorite saddle mare?"

After his application was turned down, Howard was greeted by a crowd of people on the courthouse lawn. The *Boulder Daily Camera*'s headline on the attempt read, "Rorex Says 'Neigh' to Galloping Couple." Howard's efforts

Roswell "Ros" Howard made national headlines in 1975 when he tried to obtain a marriage license to wed Dolly, his horse. *Courtesy of the Carnegie Branch Library for Local History, Boulder Historical Society Collection.*

made it into newspapers coast to coast and overseas. His attempt also elicited a comment by Johnny Carson during his national television program *The Tonight Show*.

Although Howard gained notoriety with his horse, he earned a living with his dogs. In the 1940s and 1950s, he and his wife Mary lived north of Boulder and bred pointers and setters. The couple wrote a book about their kennel experiences titled *Going to the Dogs*.

From 1967 through 1970, Howard was a regular contributor to the *Daily Camera*'s Sunday *Focus Magazine*. He continued his "Going to the Dogs" column, which he later renamed "Dog Tales."

Howard died in Boulder in December 1980.

Rorex issued her first same-sex marriage license in March 1975, one month before Howard had come to the courthouse with Dolly. At the time, state law did not specify that marriage had to be between a man and a

woman. When asked about the legality of a license between two people of the same sex, Rorex told a reporter, "My feeling was that, if it wasn't clear, I should decide every case on the side of the people."

Of Howard's attempt to wed Dolly, the clerk explained that the law specifically referred to "persons." In the end, the fact that Howard's proposed "bride" was underage wasn't an issue after all. What was important to Howard was that he had bucked the system and had made people laugh.

Howard didn't have a leg to stand on, but he did inject some humor into an otherwise controversial situation.

Charlie Steen Was a Legend in His Own Time

In 1958, shortly after Charles A. "Charlie" Steen bought a gold mine in the mountains of western Boulder County, he and his wife, M.L., got off an airplane at Stapleton Airport and hired a taxi driver to take them to inspect their new property. In an interview in 1983, the one-time multimillionaire laughed as he recalled the look in the city-bred cab driver's eyes when he navigated the steep mountain roads more than an hour's drive from the paved streets of Denver.

The historic Cash Mine was one of many investments made by this flamboyant mining tycoon who had acquired fame and fortune in uranium mining ventures in Utah. Steen became a household name in the 1950s, but few people are aware that the "Uranium King"—as he was crowned by the press—quietly lived out his retirement years in Boulder County. Steen died on January 1, 2006, in Loveland, Colorado, at the age of eighty-six.

Following World War II, the U.S. Atomic Energy Commission encouraged exploration for uranium on the Colorado Plateau. The AEC agreed to purchase ores, subsidize certain mining operations and core-drill all promising prospects. Before long, the desert was filled with Geiger counter–carrying amateurs.

Steen was just scraping by and couldn't afford a Geiger counter. Instead, he followed his professional training as a geologist and studied surface outcroppings of low-grade carnotite ore in the Big Indian Wash region near Moab. In 1952, he aimed his core drill for the carnotite he believed was trapped in an underlying anticline.

"Uranium King" Charles A. "Charlie" Steen lived out his retirement years in Boulder County. *Courtesy of the author.*

Instead, Steen hit uraninite, a much richer uranium mineral. He staked his soon-to-be-famous Mi Vida ("My Life") claim and surrounded it with others bearing romantic Spanish names, including Te Amo ("I Love You") and Mi Corazon ("My Heart").

As the money flowed in, Steen spent freely, including the Cash Mine in his purchases. From 1958 to 1964, he hired mining geologist and Gold Hill native Russell McLellan to direct an eight-man crew to block out ore reserves and rehabilitate the mine's old workings. The Cash was never put into production as Steen, at the time, didn't need the income.

The fields Steen knew best were prospecting and mining. He lost millions when he diversified into unrelated ventures that included a cattle ranch and an airplane factory. A few years after moving his family into a mansion near Reno, Nevada, he was forced to declare bankruptcy.

Out prospecting again in 1971, Steen was seriously injured when he was struck on the head by a steel pipe swinging from a drill rig truck. A dispute with the Internal Revenue Service over deductions for business losses forced him out of his home, but a subsequent settlement allowed him to keep some of his properties, including the Cash Mine.

According to a recent obituary, Steen requested that his ashes be scattered over the Mi Vida Mine. Yet the man who became a legend in his own time spent his last twenty-three years within an hour's drive of the Cash. He called it his "ace in the hole."

Only in Boulder: Demmon's Secret to Long Life

Elizabeth "Dee" Demmon is a remarkable woman—and it's not because she's lived one hundred years but because she has lived them so well. Born in Boulder on February 11, 1910, she still has a twinkle in her eye and a sense of humor, as well as a memory that surpasses that of anyone I've ever known.

A few days ago, Dee reflected on the past as she poured me a cup of tea in the kitchen of her Boulder home—the same home she moved into with her late husband, Irv Demmon, in 1943.

"I love Boulder, and I have a good time and find friends wherever I go," she told me. Dee still lives on her own, although her neighbors

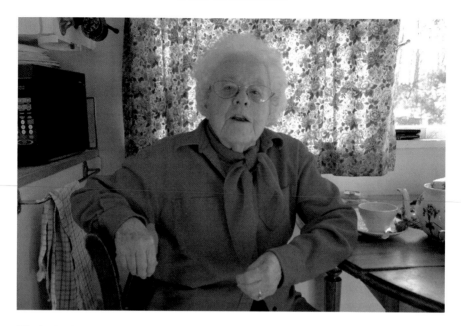

Elizabeth "Dee" Demmon credits her long life with living in Boulder. *Courtesy of the author.*

eagerly shovel her sidewalk, bring her soup and check in with her from time to time.

The Boulder native explained that her parents, as newlyweds, had moved from Ohio to Boulder in 1904 on the advice of a friend, who wrote that he had found the "perfect place to live." William Graham, Dee's father, was a partner in, and later owner of, Graham Furniture Store—which Dee's mother Anna ran for many years after her husband's death in 1932.

The Graham children (including Dee's older sister, Margaret, and younger brother, Bill) attended Mapleton Elementary School. Dee's a walking encyclopedia on the school's history and can still name all of her teachers and also identify most of the children in an all-school group photograph from 1919.

Dee went through the eighth grade at Mapleton and then spent one year at North Side Intermediate (now Casey Middle) School and graduated from State Preparatory (predecessor of Boulder High) School in 1928.

High school was where she met Irv Demmon. Dee still laughs about their first date, when Irv took her ice skating. "I fell down so much it's a wonder

he ever asked me out again," she said, adding, "We didn't have any money, but we had more fun."

After "going together" for ten years ("without shacking up," Dee emphatically stated), the couple married in the First Presbyterian Church on August 26, 1936. Dee and Irv had both graduated from the University of Colorado and had worked as schoolteachers.

Irv then began a long and distinguished career as a school administrator. In addition to raising two sons, Dee worked as a substitute teacher and taught children in their homes when they were too ill to attend classes.

Dee explained that even in elementary school her teachers "drilled in us what we should see in the world." In their retirement years, the Demmons took their educations to heart and explored Europe and walked on the Great Wall of China.

Since Irv's death, in 1994, Dee stays closer to home, but she still attends church and club meetings and keeps active. Along with her memories, Dee has her health, although she's a little miffed that her sons have told her that she's no longer allowed to water the lawn.

Her secret to long life? Dee credits her longevity to living—*only*—in Boulder.

Index

About the Author

Silvia Pettem started writing for the *Boulder Daily Camera* in the 1970s and has written the newspaper's history column since 1998. A longtime Boulder County resident, she is the author of more than a dozen books including *Separate Lives: The Story of Mary Rippon* and *Someone's Daughter: In Search of Justice for Jane Doe.*

Visit us at

www.historypress.net